# THE KOM LEAGUE
# REMEMBERED

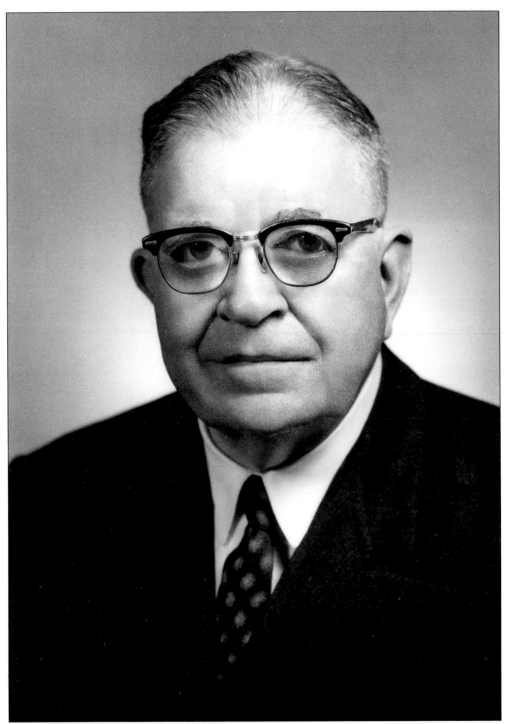

Eliel Lanyon Dale of Carthage was the primary force in the formation of the KOM League and served as its president for the playing history of the league. In order to ensure that sufficient funds were available for the operation of the league, Dale served the entire time without any type of compensation. He was a true baseball fan. (Courtesy of Robert Dale.)

# THE KOM LEAGUE
# REMEMBERED

John G. Hall

ARCADIA

Published by Arcadia Publishing
Charleston SC, Chicago IL, Portsmouth NH, San Francisco CA

Printed in Great Britain

Library of Congress Catalog Card Number: 2004110099

For all general information contact Arcadia Publishing at:
Telephone 843-853-2070
Fax 843-853-0044
E-mail sales@arcadiapublishing.com
For customer service and orders:
Toll-Free 1-888-313-2665

Visit us on the internet at http://www.arcadiapublishing.com

# CONTENTS

Acknowledgments    6

Introduction    7

1.   The 1946 Season: The Inaugural Year    9

2.   The 1947 Season: Two "Powerhouse" Clubs Added    19

3.   The 1948 Season: The Dominance of Ponca City and Independence Commences    33

4.   The 1949 Season: The Season of "The Stars"    53

5.   The 1950 Season: The Clouds of War on the Horizon    69

6.   The 1951 Season: The League Suffers Attrition    97

7.   The 1952 Season: The Swan Song of a Great League    117

# ACKNOWLEDGMENTS

A book such as this is not a product of other published resource material. There are the statistics that were available through the Sporting News Official Baseball Guides each year and the local newspapers from the towns that housed KOM League teams.

From that era there were very few photos taken by the media. There was the usual team photo taken each year and very little else. Most of the photos coming out of the old KOM League were the work of amateur photographers using their Kodak Brownie cameras.

There weren't any photojournalists hanging out in the small Class D sites located in Southeast Kansas, Northeast Oklahoma or Southwest Missouri. Only once did a KOM League player get attention by appearing in an Associated Press wire photo. That came quite by accident as an Associated Press executive was in Carthage, Missouri as guest of KOM League President, E.L. Dale. It was the opening game of the 1947 season and Jim Morris was pitching for the Miami Owls, and he defeated the Carthage Cardinals on a no-hitter. A photo was taken of Morris with President Dale at the conclusion of the game and the film was placed on a Greyhound bus and sent immediately to Kansas City. The next day it became the most famous of all KOM League photos.

This book is the product of hundreds of former players and/or their survivors who have gone into their attics and other places where old photos were stored for nearly a half-century and brought to the light of day. This book is the culmination of a 10-year search for former players and the images they have kept as a reminder of their attempt to jump on the lowest rung of the ladder of professional baseball and someday work their way up to the major leagues. Of the 1,588 young men who donned a KOM League uniform, 32 made it to the "big show" and one made it to the Hall of Fame.

# INTRODUCTION

The *KOM League Remembered* has been the title of a newsletter in continuous monthly printing since 1994. It was designed to keep a few hundred former players, family members and fans of the old Kansas-Oklahoma-Missouri League apprised of what was going on with the fellows who played the game of minor league baseball in its Golden Era. The Golden Era in this author's estimation was the time span between the end of World War II and the outbreak of the Korean Conflict.

At the close of World War II minor league baseball was "king" in the small towns of Independence, Iola, Chanute and Pittsburg in Kansas. Miami, Bartlesville and Ponca City were the early Oklahoma entries. By 1952 the town of Blackwell, Oklahoma had come into the league and by virtue of that, Carthage, Missouri, the team for which I was a batboy, was no longer a site for the minor league game. What a loss that was to a 12-year-old kid who had "lived" the previous two KOM League seasons at the Carthage ballpark.

The KOM League folded at the close of the 1952 campaign due to the Korean War and the novelty of television being available in all the KOM towns through outlying stations in Kansas City and Tulsa. The reception was horrible but on a "good day" you could see a faint image on the screen through the interference we called "snow."

Chapter One: 1946 was the first year for professional baseball in the four-state area of Kansas, Oklahoma, Arkansas and Missouri since 1942. The Western Association folded at the conclusion of that season, as had the Arkansas-Missouri League, at the mid-point of the 1941 campaign. The KOM League was filled with hardened veterans of the European and Pacific Theaters of operation along with baby-faced youngsters fresh out of high school. (In fact, some players had to leave as soon as the season concluded to enroll in classes.) The new league went with six teams in its inaugural season—the Bartlesville Oilers, Carthage Cardinals, Chanute Owls, Iola Cubs, Miami Blues, and Pittsburg Browns.

Chapter Two: By 1947 the likes of Earl Sifers, Hershel Beauchamp, and Gabby Street had worked feverishly with President E.L. Dale to expand the league from its original six teams to eight. Ponca City, Oklahoma came into the circuit as a farm club of the Brooklyn Dodgers and Independence, Kansas entered the league as farm club of the New York Yankees. The domination of these two franchises didn't show up in 1947, but the foundation was being laid for a future stranglehold these clubs would hold over the rest of league.

Chapter Three: The 1948 season saw the rise of the Independence and Ponca City franchises. The young men that the Yankees were placing in Independence would soon be finding their way into stadiums of the National and American Leagues. In a three-year span, nine graduates from the Independence club had worked their way to the top.

Chapter Four: The zenith of the KOM League was reached in 1949. The difference between first and third place was a game and a half, and the league was honing the skills of such future

big leaguers as Steve Kraly, Jake Thies, Lou Skizas, Bob Wiesler, Harry Bright, Bill Upton, Bob Speake, and a kid out of Commerce, Oklahoma, who they nicknamed, "The Comet."

Chapter Five: By 1950 the joy of minor league baseball was dimmed with the announcement of the North Koreans crossing the 38th Parallel. That was the beginning of the end for the KOM League. Young men embarking on their baseball careers knew they could be in a foreign land fighting a terrible war by the end of that season or surely by 1951. They weren't wrong. Two members of the KOM League of 1950 and 1951 paid the supreme sacrifice.

Chapter Six: The toll of war upon the availability of players and the drop in attendance hit the KOM League in 1951.Chanute and Independence dropped out of the circuit, reducing the league six teams and having an impact on overall interest. The rumors of even further cutbacks in league operation for 1952 didn't bode well for a league that had started with such promise.

Chapter Seven: Carthage—home of my beloved Cubs—was gone when 1952 rolled around. The team had moved to Blackwell, Oklahoma and was now called the Broncos. Independence, once the crown jewel of all New York Yankee Class D teams, had come back into the league wearing the same Yankee uniforms. Only this time there was a St. Louis Browns patch on the sleeve. That was all anyone needed to see to know that the old league was about to fold its tent.

The KOM League may have been short in duration but the graduates who went on to play the game in places like Yankee Stadium, Sportsman's Park and Shibe Park kept the memory of the old league alive in the hearts and minds of the faithful. Not only did the graduates do well in the sport of baseball, but also others made their mark in the entertainment and business worlds. Bert Convy, former Miami Eagle outfielder, had a long career in television and the silver screen. Jack Bumgarner played at Bartlesville, Oklahoma and many years later changed his name to Garner just as his younger brother James did. Television classics such as "Maverick" and "The Rockford Files" are part of the Garner legacy.

A number of other former KOM Leaguers were actors on television, in the movies and on the Broadway stage. Bert Convy, Robert Roman and Richard Tretter come immediately to mind. There were heroes from World War II who made the adjustment to post war baseball and others who left the KOM League to later serve their country at high levels. Kendall Moranville of the 1950 Miami Eagles took over as Commander of the Mediterranean Fleet the same day a former KOM Leaguer, Mickey Mantle, retired from the Yankees.

It was a daunting task to select the photos for this book, due to the thousands that the author has acquired over the past decade. It is hoped that the ones shared will give the reader an appreciation for the contribution the Class D KOM League had on the perpetuation of the game we call the National Pastime. This book is a pictorial of some of the fellows and towns that comprise the lore of "bush league baseball." Hopefully, this look back at the teams and the years of the short life of the KOM League will rekindle some fond memories for those who experienced it and enlighten others who were not around when a great piece of American drama was being played out on the diamonds of small town America. It may even evoke some sadness, but it is all a part of the past in which 1,588 young men gave baseball at least one year, or part thereof, out of their life.

# ONE

# The 1946 Season
## *The Inaugural Year*

Harry S. Truman, who was born at Lamar, Missouri, less than 30 miles from two KOM League cities—Carthage, Missouri and Pittsburg, Kansas—led the free world in 1946.

The hit tunes of the day were: "Sioux City Sue," "Prisoner of Love," "Shoo-Fly-Pie" and Apple Pan Dowdy," "Say it Isn't So," "Oh Buttermilk Sky," "To Each His Own," "Now is the Hour," "Full Moon and Empty Arms," "Come Rain or Come Shine," "Doing What Comes Naturally," and Tex Ritter's "You'll Have to Pay." Somehow each of those tunes seems to have a title that could have had personal significance to ballplayers.

A full weeks worth of groceries for a family of four could be purchased for less than $20. You could take a round trip on the Greyhound of 1,000 miles for less than $10. You could gain access to a movie for 35 cents, a Coke was still a nickel, and a postage stamp 3 cents. DDT was still recommended for all types of spraying and x-ray machines were placed in the finest shoe stores so you could see how your new shoes fit. The Boston Red Sox and the St. Louis Cardinals were winning pennants, and the best basketball team in the country was a semipro team called the Phillips 66 Oilers located in the KOM League city of Bartlesville, Oklahoma.

With the cessation of hostilities in the European and the Pacific Theaters of operation the young men of America headed home. Many returned to resume their careers in baseball—at some level.

Some came back with physical and mental conditions too severe to take up the game they loved. Others faced the rejection of major league scouts due to advanced ages of 23 to 25 years. Some (most) fibbed about their age and hoped that they would be picked up by an organization and afforded the opportunity to eventually play in the "big-time."

Others knew the "big-time" probably wouldn't see them rise much higher than Class D. So, they played the game in such cities as Chanute, Iola, Miami, Pittsburg, Carthage, and Bartlesville with all the intensity that they would have, had they made it to New York, Boston, Detroit, Chicago or St. Louis.

The bases in Class D were the same distance apart as they were in the majors. The pitchers mound to home plate was the same distance in Class D as it was in the American or National Leagues. Much to the surprise of some young batsmen, the hurlers of the KOM League could get the ball to home plate as rapidly as most of the guys playing at the top rung of baseball. The major difference in Class D was that neither the hurler nor the batter was ever sure where the ball was going. Batters faced these young arms with fear in their hearts, and to "dig-in" on such hurlers was akin to digging one's own grave.

The boys just home from the horrors of war were joined by young men who in some cases were still in high school. Class D teams were primarily a combination of "seasoned veterans," ages 23 to 25 and home after four years of war, and 17 to 18-year-old boys just fresh from four years in high school.

This melting pot was the beauty of the "lowest rung" of the National Pastime. The townsfolk adopted these young men, took them into their homes and hearts, and it was a relationship that lasted many years after the young men left that city and, eventually, baseball.

Professional football was only played on Sunday and without TV coverage. Professional baseball was "the only game in town" and it was being offered to fans in every state in the union except Vermont and Wyoming. It was **1946**—a great time to be alive and a baseball fan.

### Summary of KOM League Data for 1946

| Team Standings | Won | Lost | Pct. | GB |
| --- | --- | --- | --- | --- |
| Chanute Owls | 68 | 53 | .562 | — |
| Miami Blues | 69 | 54 | .561 | — |
| Iola Cubs | 63 | 57 | .525 | 4.5 |
| Pittsburg Browns | 61 | 59 | .508 | 6.5 |
| Carthage Cardinals | 54 | 66 | .450 | 12.5 |
| Bartlesville Oilers | 47 | 73 | .392 | 20.5 |

*Iola and Chanute tied 3-3 in playoff games that counted. Chanute won another contest that was later ruled a "non-game." The series never was settled.*

### League Leaders

#### Batting
Average: .346, Newton A. Kiethly, Miami Blues
Home runs: 10, Larry Singleton, Iola Cubs
RBI: 82, Adolph "Buzz" Arlitt, Carthage Cardinals
Stolen bases: 53, Emil Malattia, Chanute Owls.

#### Pitching
ERA: 1.93 Ross Grimsley, Chanute Owls
Wins: 18-5, Grimsley; 18-9, Oscar "Pappy" Walterman, Carthage Cardinals
Strikeouts: 295, Ross Grimsley
Shutouts: No records kept in 1946.

#### Attendance
Bartlesville: 46,822
Carthage: 47, 400
Chanute: 41,600*
Iola: 45,231
Miami: 49,266
Pittsburg: 42,932
*estimated*

### Players from 1946 KOM League Teams Who Made it to the Major Leagues
Pittsburg: Don Lenhardt
Carthage: Cloyd Boyer and Robert Habenicht
Chanute: Ross Grimsley

### Managers in the KOM League in 1946 with Previous Major League Experience
Bartlesville: Claude Willoughby

Jim Crandall (left) who managed Pittsburg in its first year of KOM League affiliation is shown here with his father Otis "Doc" Crandall. The elder Crandall was a former big leaguer with the New York Giants and four other clubs in a 10-year period (1908–1918). After his major league career, where he won 106 games, Doc went on to become a fixture in the Pacific Coast League, winning over 200 games. Jim's professional career started in 1932 and had played, prior to taking over the reigns of the Pittsburg club, as high in professional baseball as the Pacific Coast League and the American Association. He was a very popular figure among KOM League fans. He stayed at the managerial level of minor league baseball through 1955. (Courtesy of Jeanne Mitchell-Grisolano.)

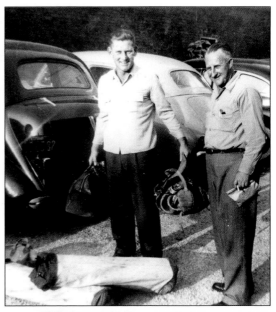

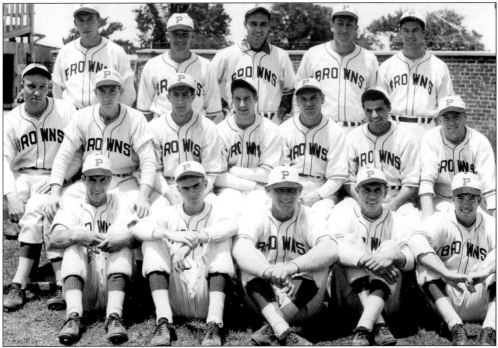

The 1946 Pittsburg Browns, pictured from left to right in this photo, include (front row) Gordon Hernandez, Earl Fisher, Jimmy Crandall, Emery Wilson, and Milt Ward; (middle row) Ed Fowler, Dave Cox, Mike Bernadette, Bill David, Jim Streberger, Tom Caciavely, and Milt Bankhead; (back row) Al Bakunas, Bill Waggoner, Frank Tursic, Marty Ryll, and Nelson Beam. Don Lenhardt joined this team in July of the 1946 season and was a starter for the St. Louis Browns in 1950. He became the first KOM League graduate to earn a full-time spot on a major league roster. (Cloyd Boyer of the 1946 Carthage Cardinals appeared briefly for the St. Louis Cardinals in 1949.) (Courtesy of Carla Foresyth.)

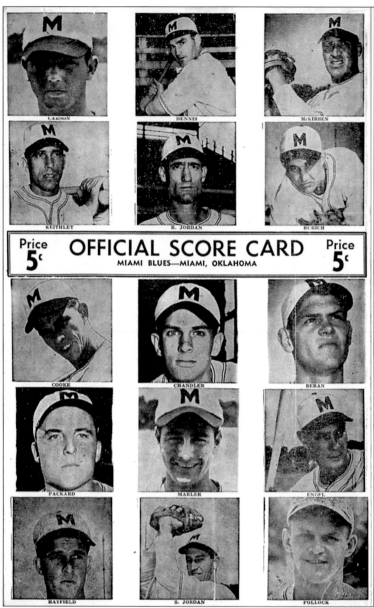

Scorecards in the KOM League were not that common. The 1946 Miami Blues had two versions for their first year of KOM League operation. The cards were an attempt to reflect the current roster. In this version, from left to right and top to bottom, are: Dudley Carson, Dave Dennis, Harve McKibben, Newt Keithly, Ray Jordan, Dale Burich, Jimmy Cooke, Bill Chandler, Joe Beran, Loren Packard, Ralph Marler, Joe "Oscar" Engel, Rex Hatfield, Steve Jordan and Joe Pollock. Miami was where a young boy from Commerce, Oklahoma used to attend games. He would attempt to shag batting practice balls and the local Miami players would take his glove and throw it over the fence. He never forgot those incidents and made references many years later, in public forums, as to how some of those Miami players were his heroes until they treated him so badly. The kid was Mickey Mantle. The Miami player who he admired to the end was "Jumpin' " Joe Pollock. (Courtesy of the Pollock family.)

The 1946 Carthage Cubs, pictured from left to right, are (front row) Ray Coss, Oscar "Pappy" Walterman, Joe Como, Robert Cloutier, Glen Koepke, and Fred Sudol; (middle row) Pat Davis (batboy), Ray Kolafa, John Oberkirsch, Frank Borghi, Don Angove, Bill Rogers, and Bill Buck; (back row) Buzz Arlitt (manager), Laverne Etting, Bill Hardegree, Duane "Whitey" Ballou, and George Hosp. Frank Borghi performed at Carthage for parts of the 1946 and 1947 seasons. His greatest claim to fame was soccer. In 1950 he was the goalie who helped the United States upset England at the World Cup games in Belo Horizonte, Brazil. (Courtesy of Oscar Walterman.)

Bob Curley models an early 1946 photo of the Chanute Owls. He noted, "This is a pretty 'scroungy' uniform only worn a week or so." The St. Louis Cardinals and then the Cincinnati Reds drafted Curley. He was within one roster cut of making the 1952 Reds club, losing out to Joe Nuxhall who was making his first appearance with that club since 1944. Curley retired from the game following the 1953 season. (Courtesy of Bob Curley.)

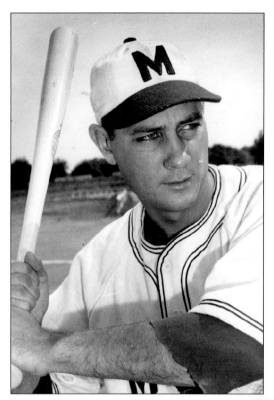

Oscar Engel played third base for the Miami Blues following his discharge from the United States Navy. He was living in Amarillo, Texas after his military service and was signed to a Miami contract by Ted Vernon, another Amarillo native. Vernon was actually the owner/operator of the Miami franchise. When the "czar" of minor league baseball heard of how the club was operated he was "much incensed." Since he didn't find out about it until the conclusion of the season it was too late to rectify the matter. In 1947 the club was operated as an affiliate of the Topeka Owls of the Class C Western Association. (Courtesy of Oscar Engel.)

Frank "Goldie" Howard started his baseball career with Springfield, Missouri in 1933. His promising career was cut-short by a head-on collision with a shortstop while playing left field at Cedar Rapids, Iowa. Howard missed most of the 1935 season before resuming his career. He played as high as the International League and had some of his more "glorious" years with the national powerhouse teams of the Wichita Boeing Bombers during WW II. Howard led Chanute to the first KOM League pennant. He was hired by the New York Yankees, on the recommendation of famed scout, Tom Greenwade, to manage their Independence, Kansas club in 1947. There he finished last with very limited talent. In 1948 the talent picked up and the old spitballer, Burleigh Grimes, had Howard removed as manager. (Courtesy of Bernie Tye.)

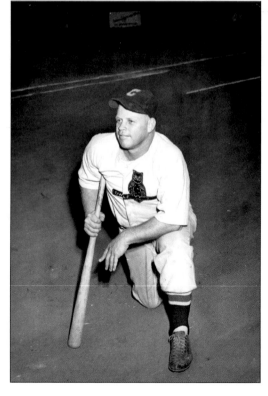

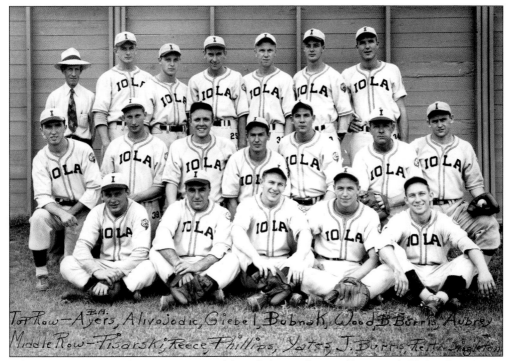

Top Row—Ayers, Alivojodic, Giebel, Bubnak, Wood, B.Burris, Aubrey
Middle Row—Pisarski, Reece, Phillips, Yates, J. Burris, Reitz, Singleton

Iola's 1946 entry into the KOM, pictured from left to right, are (front row) Gaspar Pivarunis, Nick Najjar, Walt Dunkovich, Buck Walz, and Alba Etie; (middle row) Gene Pisarski, Max Reece, Bob Phillips, Jim Yates, John Burris, Al Reitz, and Larry Singleton; (back row) Lloyd Ayers (business manager), Nick Alivojvodic, Gordon Giebel, Andy Bubnak, Richard "Whitey" Wood, Bob Burris, and Ken Aubrey. (Courtesy of Richard "Whitey" Wood.)

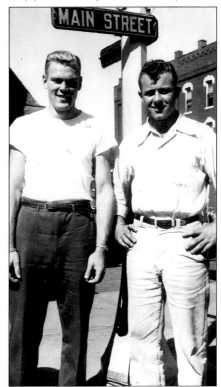

Jim Hansen (left) and Joe Kroneberg wait around on a hot summer afternoon in Chanute, Kansas for an evening contest. Hansen, a native of Omaha, played fullback for both the universities of Nebraska and Iowa during WW II. Kroneberg had been in the submarine fleet during the war and was not all that excited about rural America. According to his teammates he called everything he saw in Chanute "big." When he would see the team bus, pass a building or view any other landmark in town he would use the term "big" in derision. (Courtesy of Jim Hansen.)

15

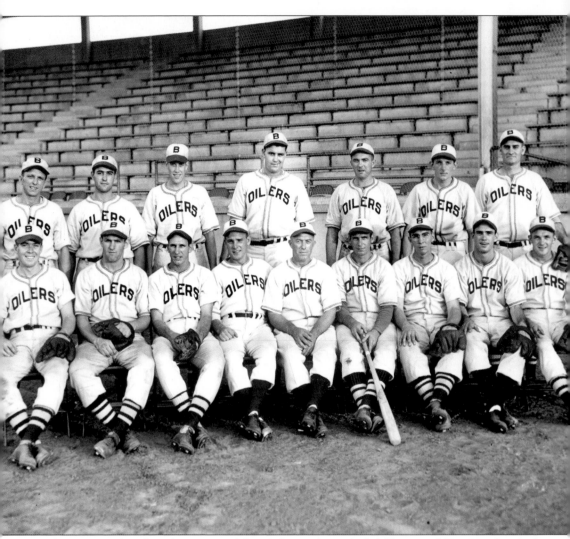

The 1946 Bartlesville Oilers, pictured from left to right, included (front row) Wes Nettles, Carl Del Grande, Howard Weeks, Earl "Ike" Henderson, Claude Willoughby (Manager), Jerry Cross, Bill Glenn, Jack Bumgarner, and Bill Waggoner; (back row) Jack Jordan, Keith Willoughby, Jeff Peckham, Bob Horsman, Ervy Carroll, Ed Suvada, and Wayne Grose. Claude Willoughby had spent seven years in the National League, from 1925 to 1931. He was a native of Fredonia, Kansas, not that far from Bartlesville. His son, Keith, who played first base on the 1946 Oiler club, became a United States judge for the Western District of Kansas. Jack Bumgarner, a second year pitcher from Norman, Oklahoma, played professional baseball for 10 years and later changed his last name to Garner. He and old brother James both became actors. (Courtesy of Carl Del Grande.)

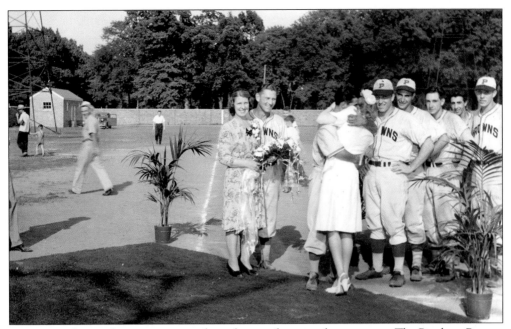

Marriages at home plate were an attendance booster for minor league teams. The Pittsburg Browns paid for the wedding of second baseman, Tom Caciavely and his bride. Manager Jim Crandall and his wife look on as the Browns players line up to kiss the bride. Caciavely became the largest Ford dealer in the metropolitan St. Louis area for many years. (Courtesy of Jeanne Mitchell-Grisolano.)

Marye Oliver sits on the grandstand wall at Miami, Oklahoma with her favorite baseball player, Joe Pollock. Pollock was a native of Cleveland, Ohio and had joined the Miami club after a brief stint in early 1946 at Muskogee, Oklahoma of the Western Association. On November 16, 1946, Joe and Marye were united in marriage for 57 years. In July of 2003 Joe passed away. In early 2004, Marye going through the old family pictures and found the negative that produced this picture. Until that day in 2004 she had never seen the photo. (Courtesy of Marye Pollock.)

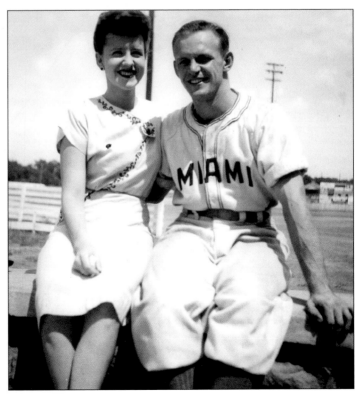

Bill Staker played for the Pittsburg Browns for parts of the 1946 and 1947 seasons. This photo was taken a year later when he played for the Aberdeen, South Dakota Pheasants of the Northern League. Staker's mode of wearing the uniform in a professional manner is something current day players should emulate. (Courtesy of Bill Staker.)

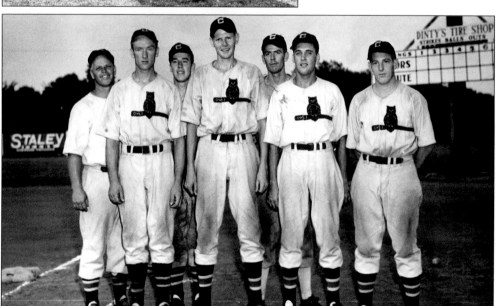

Dirty uniforms were the norm for most KOM League teams. The teams usually left town with clean uniforms and they didn't see the cleaners until the end of each trip, which often lasted a week. Any former batboy who had to unload those uniforms to send out for cleaning doesn't have an ounce of nostalgia for those "stinky" things. These 1946 Chanute Owls are modeling their dirty duds. They are, from left to right, Goldie Howard, Crow Johnson, Ray Etzel, Lee Dodson, Robert "Red" White, Ross Grimsley Sr., and Bob Curley. (Courtesy of Bernie Tye.)

# Two

# The 1947 Season

## *Two "Powerhouse" Clubs Added*

Recalling the events of 1947 doesn't seem that it has been that long ago. The man who put "America on wheels," Henry Ford, died at the age of 83. The French ship, Grandcamp, exploded and caused a chain reaction that killed 377 persons in Texas City, Texas. The structure of the Cabinet of the United States was changed and James Forestall was named the first Secretary of Defense. The job must have been too much for him, for two years later he jumped to his death from the 13th floor of the Bethesda Naval Hospital.

The control of the British Empire was loosened significantly when England granted independence to India and Pakistan. That was not the only news going on from the British Empire that year. Queen Elizabeth and Prince Philip tied the knot in London.

On the political scene an actor was testifying before the House un-American Activities Committee about Communists in the movie industry. Ronald Reagan appeared in his capacity as President of the Screen Actors Guild. At that time Ron was a Democrat and wore glasses.

Howard Hughes made headlines in 1947 when he flew his "Spruce Goose" for the first time. The replacement for the vacuum tube for TV's and radios was invented in 1947—the transistor. Speed was in the news when West Virginian, Chuck Yeager, became the first human to break the sound barrier.

Sports were in the news in 1947, other than in the KOM League. Mauri Rose won the Indianapolis 500 at an average speed of 116.3 mph. Babe Didrickson had not met George Zaharias as yet. She became the first woman to win the British Open. Jack Kramer was the Wimbledon Tennis champ and Joe Louis reigned as heavyweight champion with a decision over Jersey Joe Walcott.

On the baseball scene a virtual dynasty was being formed in the American and National Leagues. The New York Yankees and Brooklyn Dodgers met in the World Series and it seems as though they did that annual rite of fall for another decade. Class D farm clubs of the Yankees and Dodgers entered the KOM League in 1947. Neither did all that much, but in succeeding years the Ponca City Dodgers and/or the Independence Yankees were the two most dominate clubs in the league.

The 1947 KOM League season belonged to the Miami Owls. They were pennant winners and playoff champions. Loren Packard led the Owls in hitting and Jim Morris did the same in pitching.

The league drew 372,100 fans and set the all-time high of providing jobs to 352 players. Chanute led the league in player turnover with 58 players trying on the uniform that year. It didn't fit too many of the guys for very long.

Baseball had now caught on well in the lowest rung of organized baseball and the guys who played it are featured in this tribute to 1947.

| Team Standings | Won | Lost | Pct. | GB |
|---|---|---|---|---|
| Miami Owls | 76 | 49 | .608 | — |
| Iola Cubs | *69 | 54 | .561 | 6 |
| Pittsburg Browns | 69 | 54 | .561 | 6 |
| Bartlesville Oilers | *68 | 56 | .548 | 7.5 |
| Carthage Cardinals | *66 | 59 | .528 | 10 |
| Ponca City Dodgers | *61 | 62 | .496 | 14 |
| Chanute Athletics | 44 | 80 | .355 | 31.5 |
| Independence Yankees | 41 | 80 | .339 | 33 |

*Miami beat Iola 4 games to 1 in the first playoffs in league history to go the distance.*

## League Leaders

### Batting

Average: .364, Loren Packard, Miami Owls. *Packard Beat out R.T. Upright of the Bartlesville Oilers by .0064. Woody Fair of Carthage was hitting .380 when he was sent to Winston-Salem, North Carolina in July.*

Home runs: 20, Jim Baxes, Ponca City Dodgers

Stolen bases: 69, Joe Pollock, Pittsburg Browns and Iola Cubs.

### Pitching

ERA: 3.22, Carroll "Red" Dial, Bartlesville Oilers

Wins: 22-8, Carroll Dial

Strikeouts: 240, Jim Morris, Miami Owls

Shutouts: 4, Carroll Dial.

### Attendance

Bartlesville: 64,074

Carthage: 42,838

Chanute: 34,758

Iola: 39,862

Miami: 53,119

Pittsburg: 59,435

Independence: 22,460

Ponca City: 55,554

### Players from 1947 KOM League Teams Who Made it to the Major Leagues

Bartlesville: Roy T. Upright and Bill Pierro. Pierro had another season with Bartlesville in 1948.

Ponca City: Dimitrios "Jim" Baxes, Galeard "Gale" Wade and Christopher Kitsos.

Chanute: Vernon "Jake" Thies. Thies played in the KOM League from 1947 to 1949.

Independence: Harry Bright. Bright was sent packing by manager Frank "Goldie" Howard for reading comic books in the dugout. Bright showed up in the KOM League once more in 1949 at Miami, Oklahoma.

Carthage: Eddie Vargo was a catcher for this KOM League team. Following a couple of injuries he gave up playing the game and was a National League umpire for over two decades.

Ponca City: Catcher, Jack Wanda Blaylock was the first graduate of the KOM League to appear with a Major League team. He became the bullpen catcher for the 1948 Brooklyn Dodgers.

### Managers in the KOM League in 1947 with Previous Major League Experience

Chanute: Charles Bates

Ponca City: Boyd Bartley managed Ponca City from 1947 to 1950 and then again in 1952.

Pittsburg: Jimmy Crandall's father, Otis, was a former big league hurler with the New York Giants and Carthage manager Al Kluttz had a brother, Clyde, who was catching for the Pittsburgh Pirates in 1947.

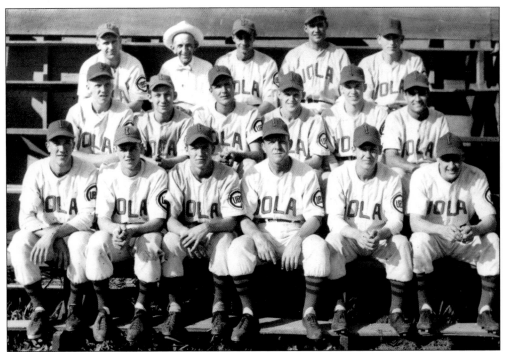

Iola was finishing its final year as an affiliate of the Chicago Cubs. Team members, seen here from left to right, included (front row) Fred Lablanc, Bob Hewson, Buck Walz, Al Reitz (manager), Jim Yates, and Hal Fortine; (middle row) Dick "Whitey" Wood, Alba Etie, Ken Aubrey, Joe Pollock, Jesse Raines, and Leo Blandina; (back row) Oscar "Pappy" Walterman, John Barley (business manager), Jake Curnal, Paul Vickery, and Roy Switzer. By the 1947 season, Al Reitz was entering his 25th year in baseball. Most of it was spent as a pitcher who earned the designation as an "iron man" by not only pitching but also winning both games of a doubleheader. Bob Hewson played at Iola for two seasons and between the 1947 and 1948 campaigns, played professional basketball for the Chicago Stags. Paul Vickery became the business manager for the Ponca City Dodgers in their final two KOM League seasons. (Courtesy of Richard "Whitey" Wood.)

The 1947 Independence Yankees were one of three KOM League clubs for which a team photo was never located. In this photo, from left to right, are team members Don Benson, Richard Stokes Dodson and Wally Reed. Benson, a pitcher, was both the top winner and loser for that club, posting a 16-18 record that season. (Courtesy of Richard Stokes Dodson.)

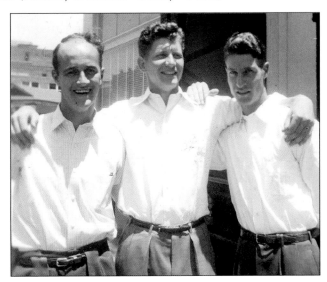

Carlton Orville Post was a left-handed pitcher for the 1947 Pittsburg Browns. He was one of the "favorites" of Bob and Loretta Mitchell who fed and befriended the Browns players throughout the tenure of that KOM League franchise. Post played minor league baseball until 1959. He played at the Triple A level in the International, American Association and Pacific Coast League. (Courtesy of Jeanne Mitchell-Grisolano.)

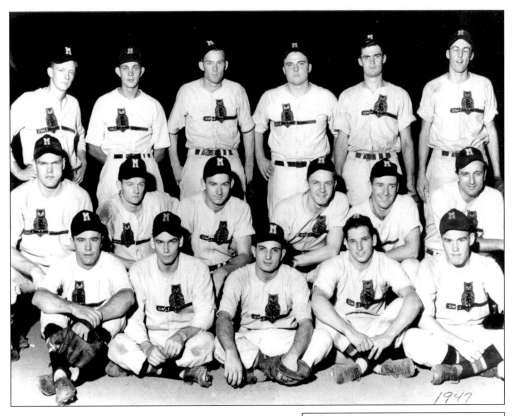

The 1947 Miami Owls members, pictured from left to right, are (front row) Ray Mazzucco, Len Worthington, Tom Tarascio, Les Harris, and Travis Kunce; (middle row) Jim Hansen, Erv Scheurman, Bob Hegwood, Marty Debish, Nathan Waterman, and Bill Davis (manager); (back row) Jim Morris, Walter "Zeb" Snider, Jim McGhee, Loren Packard, Curtis Darnell, and Hank Kelly. (Courtesy of Tom Tarascio.)

This 1947 Independence home schedule had the following on the reverse: "On Monday, April 28, 1930, the first night game in organized baseball was played at Independence, Kansas, in Riverside Stadium, present home of the Independence Yankees. This precedent-shattering and history-making game was played between the Independence Producers and the Muskogee Chiefs of the Class C Western Association and was won by Muskogee 13 to 3. Second club in organized baseball to pioneer night baseball was Des Moines of the Western League in a nationally broadcast game against Wichita on May 2, 1930."

## YANKEES AT HOME
### 1947

| April 30, Iola |
| --- |
| May 1, 2, Iola |
| May 9, 10, 11, Carthage |
| May 15, 16, 17, Pittsburg |
| May, 18, 19, 20, Chanute |
| May 24, 25, 26, Ponca City |
| May 27, 28, 29 Bartlesville |
| June 1, 2, 3, Miami |
| June 10, 11, 12, Iola |
| June 19, 20, 21, Chanute |
| June 25, 26, 27, Pittsburg |
| June 28, 29, 30, Chanute |
| July 4, 4, 5, Ponca City |
| July 6, 7, 8, Bartlesville |
| July 13, 14, 15, Miami |
| July 22, 23, 24, Iola |
| July 31, August 1, 2, Carthage |
| August 6, 7, 8, Pittsburg |
| August 9, 10, 11, Chanute |
| August 15, 16, 17, Ponca City |
| August 18, 19, 20, Bartlesville |
| August 24, 25, 26, Miami |

COMPLIMENTS OF
OAKES PRINTING COMPANY
INDEPENDENCE, KANSAS

23

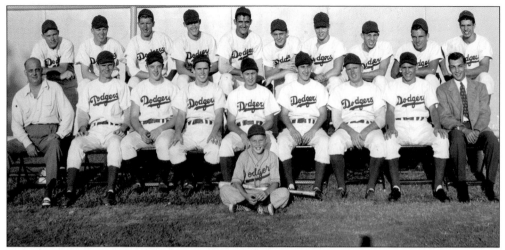

The Ponca City "brass" made the effort to identify those in their 1947 team photo by typing names and affixing them to the photograph. Pictured from left to right, are: (front) Larry Goff (batboy); (first row) Ted Parkinson (president), Phil Adams, Roland Wiblemo, Art Billings, Boyd Bartley (manager), Howie Fisher, Jack Blaylock, Keith Baker, Owen Martinez, (business manager); (second row) Gale Wade, George Fisher, Tony Brzezowski, Herb McCoy, Mel Waters, Biff Jones, Bill Hodges, Bill Boudreau, Dale Hendricks, and Jim Baxes. There are three former or future major leaguers in this group. Manager Boyd Bartley appeared in nine games with the 1943 Brooklyn Dodgers and had the longest tenure of anyone in Dodger history. He scouted many years after leaving the managerial ranks and his number one ran signee was Orel Hershiser. The other future major league performers on this team were Gale Wade and Jim Baxes. Jack Blaylock was promoted to the Brooklyn Dodgers in 1948 as their bullpen catcher. (Courtesy of Bob Dellinger.)

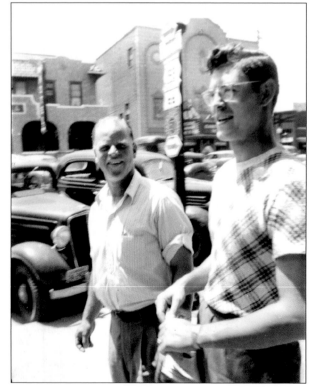

Goldie Howard (left) is seen during a road trip to Ponca City, Oklahoma. The Jens-Marie Hotel is in the background and John Cochrane is to his left. (Courtesy of Richard Stokes Dodson.)

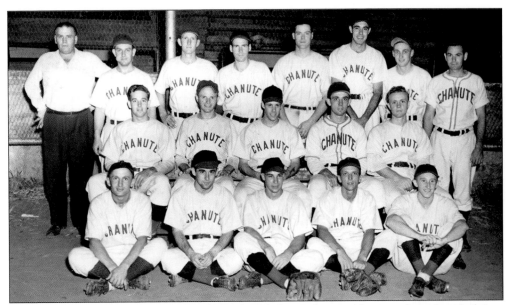

The 1947 Chanute Athletics in this photo, from left to right, are (front row) unidentified, Lou Bejma, Bobby Johnson, Jack Jordan, and Francis Urban; (middle row) Sam Dixon, Sheldon Lewis, Charles Kunkle, Don Phillips, and Bob Phillips; (back row) W.C. McCullough (team president), Joe Eperasy, Rex Simpson, Jerry Cross, Virge O'Bannon, Bernie Tye, Jake Thies, and Charles Bates (manager). Members of this team with major league experience were manager Charles Bates and pitcher Jake Thies. Bates played briefly for the Philadelphia Athletics in 1927. Thies was with the Pittsburgh Pirates in 1954 and 1955. (Courtesy of Sam Dixon.)

John "Skip" Baas was a native of Louisville, Kentucky and a member of the 1947 and 1948 Pittsburg Browns. By 1951 he was a member of the US Army. (Courtesy of Jeanne Mitchell-Grisolano.)

Woody Fair was one of the most prolific batsmen in KOM League history. He had been the Most Valuable Player for the Durham Bulls of the Carolina League in 1946. He managed the Carthage Cardinals through July of 1947. His batting average was .380 when he was relieved of his managerial duties. Fair claimed the reason the St. Louis Cardinals moved him was due to their getting tired of him asking for a first baseman. Carthage had a very good one in Don Wichmann but he suffered a torn-achilles tendon, which ended a promising career. This photo was taken at Winston Salem, North Carolina shortly after Fair left Carthage. The player behind him is future big league hurler, Harvey "The Kitten" Haddix. (Courtesy of Woody Fair.)

Joe Beran was one of five brothers who played minor league baseball. They came from a wheat farming family in Odin, Kansas. Joe was the most prolific home run hitter among his brothers Lee, Eugene, Robert and Jerry. Aside from Mickey Mantle, Joe Beran had more homers in a single season, in professional baseball, than anyone who played in the KOM League. Beran hit 37 homers with Hutchinson, Kansas of the Western Association in 1953. For comparative purposes, Mantle hit seven KOM League round-trippers in 1949 and Beran had 13 in 1948. The 1948 total was amazing since a very "dead ball" was used by the league that season. (Courtesy of Bob Dellinger.)

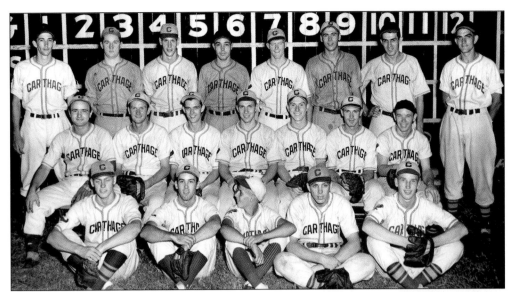

1947 Carthage Cardinals, pictured from left to right, are (front row) Hank Zich, Stewart McMillan, Pee Wee Smith (batboy), Ray Coss, and Roger Vanderweide; (middle row) Charles Antzak, Duane Coots, Jim Pirrie, Ray Diering, Ralph Rutherford, Maurice Gilliland, and Lou Ott; (back row) Jerry Baker, Ed Stubby Brown, Philip Fowler, Bill Buck, Bob Mahoney, Don Wichmann, Bill Struharik, and Al Kluttz (manager). Bob Mahoney was the only one of this group to make it to the major leagues. He was with the Chicago White Sox and St. Louis Browns during the 1951–52 seasons. Ray Diering's brother, Chuck, was playing centerfield for the St. Louis Cardinals and Al Kluttz's brother, Clyde, was doing the catching for the Pittsburgh Pirates during that 1947 season. (Photo was discovered on the wall of a service station in 1995 in Carthage, Missouri.)

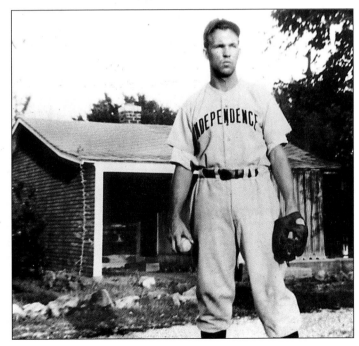

Leonard Crase of Springfield, Missouri was another young man from that town signed by Tom Greenwade and assigned to the 1947 Independence Yankees. In a tongue-in-cheek moment Crase remarked, "This photo was taken at a beautiful motel in Carthage, Missouri." (Courtesy of Leonard Crase.)

SCORE BOOK

IOLA

ATHLETIC ASSOCIATION, Inc.

1947

CUBS

Winning Number    205                    10 Cents

The Iola franchise had the best scorecards on a yearly basis of all the KOM League teams. In fact, Carthage in its six-year run in the KOM League never produced one. Scorecards throughout the history of the KOM League were either a nickel or a dime. You could purchase a season pass for $20 for all home games. That was a savings of $4 if tickets were purchased on a single game basis. (Courtesy of Jim Yates.)

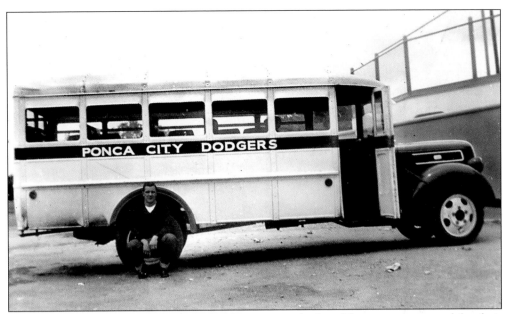

The mode of transportation in the KOM League was the bus. They were renowned for their ability to break down on each road trip. There weren't many features of those ancient machines that were admirable. This Ponca City version of "transportation" had seats that faced forward in the front and back of the bus while those in the middle faced the center aisle. Those with motion sickness had a difficult time each time they boarded up for a road game. Here, Leon Irwin guards the "only good tire." (Courtesy of Edward Grove.)

Bill McFarland was the first baseman for the 1947 Independence Yankees. He made it as far as the Indianapolis Indians in the American Association by 1950. (Courtesy of Leonard Crase.)

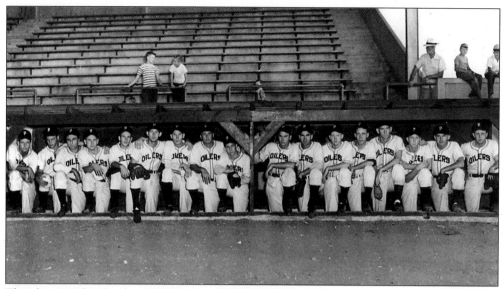

The photographer for the 1947 Bartlesville Oilers made it difficult to figure out just who was in this photo. After a "considerable" amount of research, and the memory of Al Solenberger, the team was identified, from left to right, as Ed Willshaw, Ralph Liebendorfer, Nick Najjar, Lou Tond, Ken Galbraith, R.T. Upright, Carroll "Red" Dial, Ed Marleau (manager), Al Solenberger, Elmo Maxwell, Lou Godla, Jim Fink, Bill Pierro, Wayne Caves, Jess Nelms, Bill Waggoner, and Charles Stock. From this team, Bill Pierro of Brooklyn, New York made it to the big leagues in late 1950. His career ended as the 1951 season was beginning when he fell victim to encephalitis. (Courtesy of Al Solenberger.)

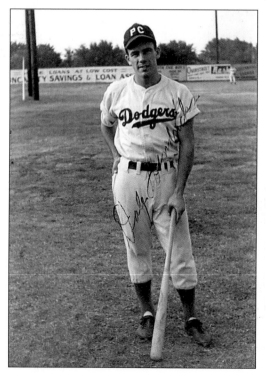

Dale Hendricks of Bremerton, Washington was a member of both the 1947 and '48 Ponca City Dodgers. His career lasted until 1950. During his final season he was with Miami of the Florida International League, Asheville, North Carolina of the Tri-State League and Lancaster, Pennsylvania of the Inter-State League. Hendricks loved the game and as much as he does his three-quarter wolf and one-quarter malamutes he raises in Bremerton, Washington. (Courtesy of Bob Dellinger.)

Jim Morris (left) gets congratulations from KOM League President, E.L. Dale. The occasion was the opening night of the 1947 season. The weather was blustery, cold and wet. Morris put a damper on the Carthage batsmen by throwing a no-hitter. The Associated Press bureau chief had been a guest of Mr. Dale for that Carthage home opener. Dale was encouraged to pose with Morris, and after the photo was taken the negative was sent by Greyhound bus to Kansas City. The next day it appeared in sports pages across the country. It was the only KOM League photo ever to receive such national notoriety. (Courtesy of Jim Morris.)

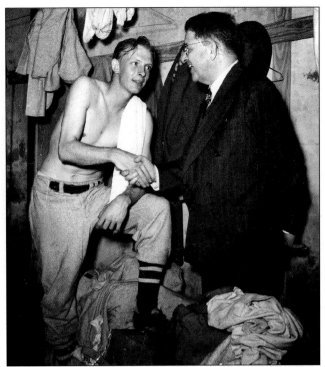

Bob Knoke (left) and John were one of the many sets of brothers who played in the KOM League. Bob was a catcher for the 1950 Independence Yankees and John hurled for the 1947 Pittsburg Browns. This photo was taken at the wedding of John and Neva. Can't prove it, but Bob and his "date" must have been the best man and brides-maid. (Courtesy of Jeanne Mitchell-Grisolano.)

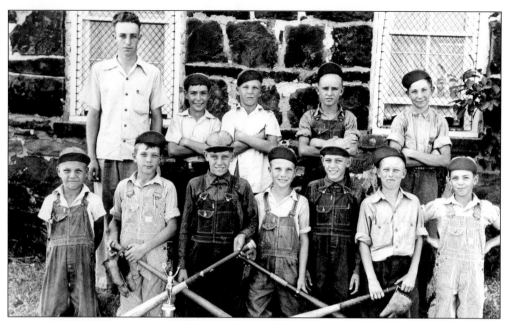

There was a lot of baseball being played in small villages in the vicinity of KOM League towns. This photo was taken in 1939 at the Red Bank School located northwest of Alba, Missouri. In the front row, from left to right, are Kenton Boyer, Ray Coss, Lynn Brown, Wayne Boyer, Leonard Brown, Harold Martin, and Royden L. Coss. In the back row are Carl Parker (teacher and coach), Buford Coss, Cloyd Boyer, Dale Moore and Walter Comstock. Of this group, Ray Coss, Wayne Boyer, Dale Moore and Cloyd Boyer all became members of the KOM League. Kenton Boyer and Royden Coss both played professional baseball but not in the KOM League. Kenton and Cloyd were both signed by Cardinal scout Runt Marr and made it to the major leagues. (Courtesy of Buford Cooper.)

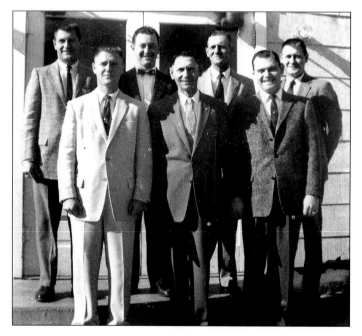

There were six Beran brothers from Odin, Kansas. Five of the six played minor league baseball and three of them—Joe, Bob and Gene—played in the KOM League. Up front are Tony, the father of the clan, and Joe. Behind them, from left to right, are Lee, Bob, Gene and Jerry. As fate would have it all the KOM League performers have passed away. However, in tribute to their departed brothers, Lee and Jerry attend the annual KOM League reunion. (Courtesy of Lee Beran.)

# THREE

# The 1948 Season

## *The Dominance of Ponca City and Independence Commences*

The 1948 season rolled around and only good things were seen for minor league baseball. The Chanute fans were finally getting a major injection by becoming a farm club of the New York Giants. All the other teams in the league were affiliated with a Major League club except the Miami Owls and they were hooked up with the Topeka Owls who gave the KOM League its first two pennant winners.

1948 was a year of radical social change. Leroy Satchel Paige, who had toiled in the Negro Leagues, and for numerous semi-pro teams for 23 years, became a member of the Cleveland Indians on July 7. Three weeks to the day later the United States Army officially ended segregation and the University of Oklahoma was forced to admit the first black person in history to its law school.

Social change was also accompanied by unrest in the world. Mahatma Gandhi was assassinated and the United States and Britain started airlifts to the blockaded city of Berlin.

The world was being entertained with prizefights—at a time when they didn't bite ears off—and political campaigns. Joe Louis remained World Heavyweight Champ by knocking out Jersey Joe Walcott on March 1. Thomas E. Dewey and Earl Warren headed up the ticket that was going to sweep the Republicans back into the White House while the Democrats were saddled with the "losing team" of Harry Truman and Alben Barkley.

Before the Republicans could nail the coffin on the Truman-Barkley ticket, General John "Black Jack" Pershing died. The Japanese military commander, Tojo, was sentenced to hang in late 1948 and Lamar, Missouri native Harry Truman was elected to lead the free world.

If you were a moviegoer you could see Rita Hayworth and Orson Welles in "Lady from Shanghai" at your local theater. In many instances the admission was 35 cents for adults and 10 cents for children. Few theaters were air-conditioned but neither was anything else except the local ice and cold storage plant.

Many of the people of my acquaintance walked to where they wanted to go, stayed home or rode around in an old Model "A" Ford. However, if you had the money, and could somehow get to the Greenlease Automobile agency in Kansas City, a Cadillac Hydromantic was selling for the astronomical price of $2,833.

London was the site of the 1948 Olympics but few people saw them. The only way Americans knew what was going on was to read the newspaper or see highlights of them at the movies on Fox Movietone newsreels. America captured 38 medals and the decathlon champ was a high school classmate of Ponca City Dodger Leon Irwin. While Irwin was attempting to catch pitchers like Dick Spady, Joe Tufteland, Don and John Hall and Dick McCoy his former classmate, Bob Mathias of Tulare, California was being featured on Wheaties cereal boxes.

A pioneer in aviation, Orville Wright, died on August 12 and the world lost one of its

greatest inventors. However, the name on the lips of most Americans in August of 1948 was the Bambino. Babe Ruth was nearing the end of his legendary life and the world followed closely the events that led to his death on August 16.

The KOM League followed the lead of George Trautman, the top executive of minor league baseball. This was the telegram he sent to all league presidents: "It is suggested that, in recognition of the passing of Babe Ruth, the flag fly at half staff until after the funeral and that on the day of the funeral the game be stopped at the middle of the seventh inning for one minute of silence out of respect for his memory, and that closing this period the announcer use these words. 'Babe Ruth is gone from the American scene, but will live forever in the hearts of the lovers of our game. Born in obscurity, he became a world figure, the idol of every American boy and the greatest personality our game ever produced'."

KOM League fans flocked in record numbers to see their heroes play in 1948. 387,980 souls braved floods and unbearable heat to see nearly every pitcher post ERA's under 3.00 and every batsman curse the Worth Baseball. Batters claimed hitting that ball four times made it a cube.

It was a great time for the fans of Ponca City, Independence, Bartlesville and to a lesser extent Pittsburg. The faithful in Miami, Carthage, Iola and Chanute could only hope the season would end early and 1949 would have better things in store for their teams.

### SUMMARY OF KOM LEAGUE DATA FOR 1948

| Team Standings | Won | Lost | Pct. | GB |
|---|---|---|---|---|
| Ponca City Dodgers | 79 | 47 | .627 | — |
| Independence Yankees | 74 | 46 | .617 | 2 |
| Bartlesville Pirates | 71 | 52 | .577 | 6.5 |
| Pittsburg Browns | 60 | 60 | .500 | 16 |
| Miami Owls | *58 | 66 | .468 | 20 |
| Carthage Cardinals | *51 | 67 | .432 | 24 |
| Iola Indians | 51 | 72 | .415 | 26.5 |
| Chanute Giants | **44 | 78 | .361 | 33 |

*Indicates tie  **Both ties were against Chanute.

### LEAGUE LEADERS

#### BATTING
Average: .327, William "Red" Fox, Chanute Giants
Home runs: 13, Charles F. "Bill" Stumborg, Pittsburg Browns and Joe Beran, Ponca City Dodgers
RBI: 72, Joe Beran
Stolen bases: 41, Ewing Turner, Ponca City Dodgers.

#### PITCHING
ERA: 1.94, Harland Coffman, Independence Yankees
Wins: 18-5, Harland Coffman
Strikeouts: 300, Bill Pierro, Bartlesville Pirates
Shutouts: 6, Bill Pierro

#### ATTENDANCE
Bartlesville: 64,090
Carthage: 36,525
Chanute: 32,561
Iola: 42,770
Miami: 33,716
Pittsburg: 53,743
Independence: 46,270
Ponca City: 78,305

PLAYERS FROM 1948 KOM LEAGUE TEAMS WHO MADE IT TO THE MAJOR LEAGUES
Bartlesville: Bill Pierro
Carthage: Robert Mahoney
Chanute: Vernon "Jake" Thies
Independence: Al Pilarcik and Jim Finigan

MANAGERS IN THE KOM LEAGUE IN 1948 WITH PREVIOUS MAJOR LEAGUE EXPERIENCE
Ponca City: Boyd Bartley
Independence: Burleigh Grimes (interim basis)
Chanute: Al Smith (the man who stopped Joe DiMaggio's 56 game hitting streak).

In 1948 Bernie Tye joined the Miami Owls. The perennial good-guy of the KOM League had spent time with both Chanute and Iola that year before whacking the Iola team owner across the face with his ball glove. As Bernie told the story, Iola owner Earl Sifers made a derogatory comment about his performance on defense. Following that game, Tye was on the bus with the Miami Owls as their newest member. Bernie at over 6-foot-7 and Miami second baseman Tom Tarascio at 5-foot-4 formed the extremes in height in KOM League history. Forty-seven years later the pair posed at a KOM League reunion to prove that they hadn't changed a bit. (1948 photo courtesy of Gus Freeman.)

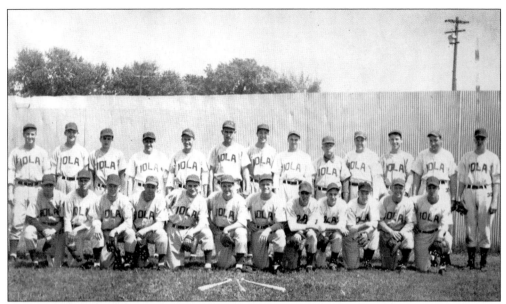

Only a few teams had photos taken during spring training. Those aspiring young men who showed up at Iola in 1948 had their photo taken and placed on both small and large postcards. Unfortunately, a regular season team photo was never taken. In this photo, from left to right, are (front row) George Murphy, Paul Box, Jessie Raines, unidentified, Larry Tarbell, unidentified, Art Sullivan, Arnold Fritz, Bob Yuhas, Eugene Berger, Jack Jordan, and Howard "Buck" Walz; (back row) George Martak, Lynn Stemme, Unidentified, Hal Fortine, Jim Yates, Al Dunterman, Fred LaBlanc, Bob Hewson, Al Reitz, Homer Cole, unidentified, unidentified, and Richard "Whitey" Wood. (Courtesy of Richard "Whitey" Wood.)

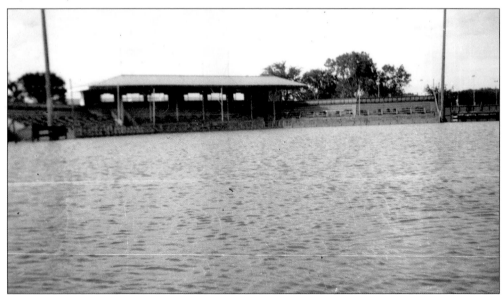

Three teams in the KOM League were located on the Neosho River. The river's course runs through Eastern Kansas and Northeast Oklahoma. Iola and Chanute in Kansas are on that river as is Miami, Oklahoma. In 1948 it made Riverside Park in Iola suitable only for swimming and fishing. (Courtesy of Richard "Whitey" Wood.)

The 1948 Independence Yankees, pictured from left to right, included (front row) Doreece Abbott (batboy), Tom Gott, Ray Haley, Dick Duda, and Al Pilarcik; (middle row) Art Quigley, Harland Coffman, Gabe Padilla, Al Thune, Paul Nichols, Dennis Jent, Lou Michels and Bill Bagwell; (back row) Keith Upson (broadcaster for KIND Radio Station), Paul Slaughter, Charlie Joe Fontana, Jim Davis, Bob Hamric, Malone Battle "Bones" Sanders (manager), Jim Finigan, and Nick Ananias. (Courtesy of Bill Bagwell and Paul Nichols.)

This photo caught Pittsburg Browns manager Don Smith "red-handed." He had been suspended by the league for a few games due to a run-in with an umpire and was not to affiliate with the team in any manner. This was an early morning workout during the time Smith was supposed to be absent from the ballpark. (Courtesy of Rex Simpson.)

Bob Yuhas had an auspicious debut with the Iola Indians. He opened the season with a no-hitter against the Independence Yankees. Prior to that, he had been a third baseman at Batavia, New York in the PONY League and Bloomingdale, New Jersey in the North Atlantic League. Yuhas spent the 1949 and '50 seasons in the Canadian-American and Middle Atlantic leagues, respectively. Bob spent the 1951 and '52 seasons in the Army. While he was serving his country, his brother, Ed, was making "big noise" with the St. Louis Cardinals. Ed Yuhas posted a 12-2 record as a relief pitcher in 1952 and came close to being selected as National League Rookie of the Year. By 1953 both of the Yuhas brothers were headed back to professional baseball. Bob was assigned to Spartanburg, South Carolina of the Tri-State League. Prior to heading for St. Petersburg, Florida for the Cardinal Spring training camp, Ed picked up a rock and threw it at a squirrel sitting in his front yard. He ruined his arm with that toss and only pitched one inning for the Cardinals in 1953. His career was over. (Courtesy of Bob Yuhas.)

The Pittsburg Browns players enjoyed eating home-cooked meals at the Loretta and Bob Mitchell home, the restaurant of choice was Otto's and the city park was a great place to go for photo sessions. The 1948 Pittsburg Browns in this "dress up" photo include, left to right, Warren Sliter, Skip Baas, Bob Paulausky, Hank Fecker, Myrl "Scooter" Hughes and Danny Kantor. (Courtesy of Jeanne Mitchell-Grisolano.)

The Miami Owls had their own version of "Murderers Row" that included Gus Freeman, Tom Kappele, Jim Hansen and Jim Manuel. These four had 50 percent of the home runs the Owls pounded out during the 1948 season. The eye-popping numbers show Kappele led the club in homers with two. That's right, two. Freeman, Kappele and Hansen had one each. The Miami club had a grand total of ten homers. Ponca City led the league with 33 and one player, Joe Beran, had 13 of that number. (Courtesy of Gus Freeman.)

Don Bruss and Al Dunterman pose while waiting to play a road contest at Pittsburg, Kansas. (Courtesy of Don Bruss.)

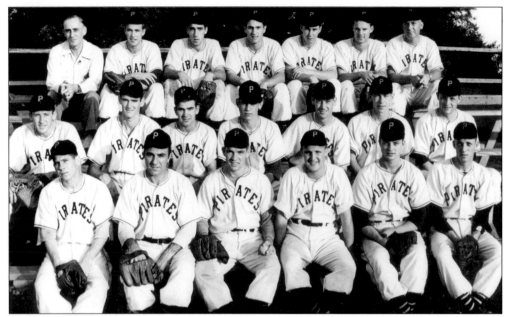

The 1948 Bartlesville Pirates, from left to right, featured (front row) Al Solenberger, Nick Najjar, Dave Elliott, Lou Tond, Johnny Girrens, and Bill Pierro; (middle row) Ray Birch, Calvin Frazer, Lou Godla, Rolf Moeller, Leroy Sanders, Don Haines, and Charles Stock; (back row) Rufus Bedford (business manager), Tex Howard, Sonny Catalano, Pete Maropis, Gary Hegedorn, Norm Carpenter, and Ed Marleau. Bill Pierro was the only member of this team to make it to the major Leagues. (Courtesy of Al Solenberger.)

The Don Day family adopted the 1948 Independence Yankees. The Days operated the Hilltop Motel in Independence, Kansas and housed many and fed even more members of that club. When Al Pilarcik got married, he spent his honeymoon in the town where he played his first year of organized baseball. In this photo, from left to right, are (front row) Jim Davis, Nick Ananias, Bill Bagwell, and Charlie Joe Fontana; (back row) Al Thune, Ray Haley, Al Pilarcik, and Jim Finigan. Finigan and Pilarcik were the two members of this team to make it to the major leagues. (Courtesy of Bill Bagwell.)

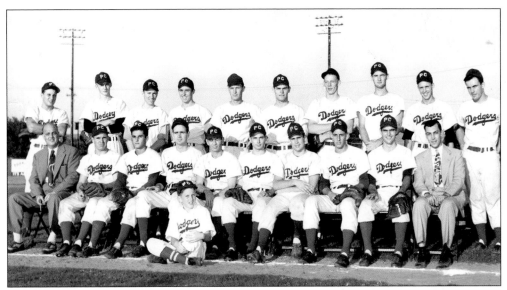

This1948 Ponca City Dodgers picture was taken at end of the season. Some "affluent" clubs had photos taken at the beginning and conclusion of each season. The season ending photos were a testament to the fellows who had endured. Endurance encompassed unspeakable bus trips, meal money that was limited to $2 per day while on the road—nothing for days the team was home, motel rooms where players were expected to sleep 2-3 to a bed without the benefit of air-conditioning, and uniforms that were made of wool and washed sometimes only once a week. Pictured, from left to right, are (front row) Ted Parkinson (president), Ewing Turner, Gene Castiglione, Alex Muirhead, Boyd Bartley (manager), Ed Grove, Leon Irwin, John Hall, Bill Delich, Owen Martinez (business manager), and Dan Spradlin (batboy); (back row) Bob Casey, Dick Spady, Gene Rogers, Dale Copps, Ray Scherschligt, Joe Beran, Don Hall, Dick McCoy, Joe Stanek, and Dale Hendricks. (Courtesy of Bob Dellinger.)

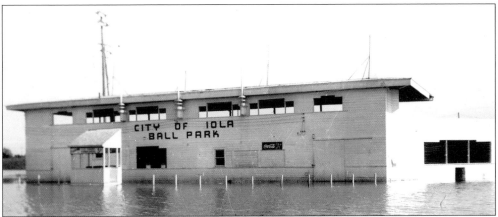

Here is another view of the ballpark at Iola in 1948, when the Neosho River forced the team to play many more games on the road than was intended. The stench, after the waters receded, is something that remained in the memory of the players who had to perform at towns like Iola, Chanute and Miami after the dry land reappeared. There were even instances of speed boat races at the Chanute ball park more as a publicity stunt than anything else. It managed to get some national press attention when it was announced that speedboat racing occurred where a few days earlier minor league baseball had been played. (Courtesy of Richard "Whitey" Wood.)

During his tenure as sports editor of the *Ponca City News*, Bob Dellinger was the best photojournalist in the KOM League. He graduated from the University of Kansas in 1947 and his first assignment was covering a baseball team that had players the same age as he was. This photo of Leon Irwin was taken during the same summer that Irwin's high school classmate, Bob Mathis, was winning the gold medal in the decathlon at the 1948 Olympics. Irwin played three years of minor league baseball before hanging up the spikes. (Courtesy of Bob Dellinger.)

Gene Castiglione was a second baseman in the Dodger organization at the wrong time to advance through the system at a rapid rate. He spent the 1948 and '49 seasons in the Class D KOM League. In his rookie year he had a fielding average of .942 and hit .220. By 1949 he fielded at a .970 clip and raised his batting average to .280. He had one more year of baseball in 1950 before entering the military in 1951. By 1953 Castiglione was back in pro ball with Asheville, North Carolina in the Tri-State League, and he ended his playing career in 1954 with Knoxville in the Tri-State circuit. (Courtesy of Bob Dellinger.)

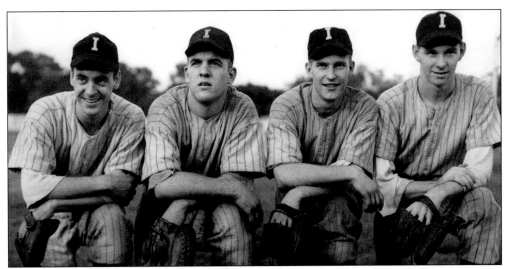

These four fellows had a lot in common. They were all Springfield, Missouri natives, signed by the New York Yankees and sent to Independence, Kansas in 1948. From left to right are Lou Michels, Ray Haley, Tom Gott and Paul Nichols. One other claim they can make is that each has been to one or more KOM League reunions where they have renewed "the good old memories." Each of these men was successful in their post-baseball careers. Michels was a Certified Public Accountant, Haley a high school Hall of Fame football coach, Gott a school administrator and Nichols a graphic artist. Nichols designed the Bank Americard logo that was seen on the left field wall at Atlanta when Hank Aaron's record breaking 715th home run was hit. (Courtesy of Paul Nichols.)

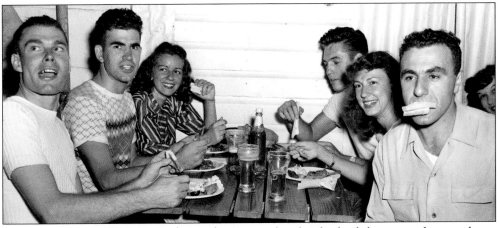

Baseball players who received $2 to $2.50 per day for food while on road trips always appreciated a good meal. When they were home they had to find any way they could to get a free meal. A couple of Bartlesville Pirates are identifiable in this photo. Second from the left is Lou Godla of McLean, Virginia who spent the 1947 and '48 seasons at Bartlesville. Nick Najjar, at far right, demonstrates the proper technique of eating a sandwich without the aid of using his hands. Najjar, a charter member of the KOM League, spent the 1946 season at Iola and part of 1947 there before being sent to Bartlesville. He spent the rest of 1947 and 1948 with that Oklahoma club. By 1950 he had given up on the game as a pitcher and went to the Bill McGowan umpiring school and returned to the KOM League in 1950 as a member of a two-man crew. (Courtesy of Lou Godla.)

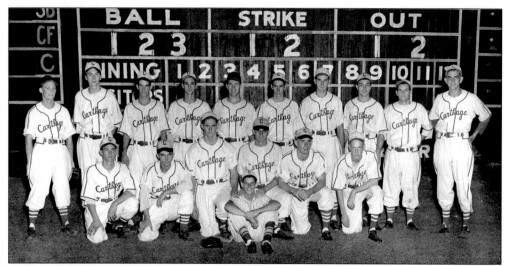

The 1948 Carthage Cardinals were the last club the St. Louis Cardinals sponsored in the KOM League. Team members, seen here from left to right, are (front row) Ken Cox, Jack Hallowell, Dave Young, Maurice Mathey, George Schachle, Dean Walstrom, and Pee Wee Smith (batboy in the foreground); (back row) Charles Williams, Don Schultz, Jack Hinkle, Jim Neufeldt, Ray Diering, Walt Marlow, Hank Wlodarczyk, Bill Buck, Art Wilson, and Al Kluttz (manager). Ray Diering, a catcher on that club, was the brother of St. Louis Cardinal centerfielder of that same era, Chuck Diering. No one else from that club made the big leagues but it wasn't due to a lack of confidence. When Jack Hallowell arrived on the Carthage scene he announced that he would make baseball fans forget Dizzy Dean. He didn't. (Photo found in Carthage service station in 1995.)

Bob Nichols and Hal Brydle, who had seen action with the 1948 Iola Indian, display the extremes of the dress code in a photo taken on Easter Sunday in 1949 at Marianna, Florida. From left to right are Nichols, Windy Johnson (manager), Gene Daily and Brydle. In the background is Al Dunterman. (Courtesy of Hal Brydle.)

This photo of Moses J. Yellowhorse has been widely plagiarized. This is the original taken by Bob Dellinger of the *Ponca City News* in 1948. Yellowhorse, of Pawnee descent, was born in Pawnee, Oklahoma and pitched for the Pittsburgh Pirates in 1921 and 1922. He was the first groundskeeper for the Ponca City Dodgers and never missed a day of work unless he was attending a tribal pow-pow. He was given the chance to umpire some home games at Ponca City during the 1948 season when the league lost a couple of umpires who fled the scene due to rowdiness of the Pittsburg fans. (Courtesy of Bob Dellinger.)

Shannon Willis Deniston, a native of Long Beach, California started the season as manager of the Pittsburg Browns. He had played professional baseball as far back as 1939 with El Paso, Texas. He also played in the Pacific Coast, International and Texas leagues at the peak of his career. In the off-season he coached football and is seen in this photo when he was line coach at Pepperdine. Deniston stayed in baseball through the 1951 season, playing at both Des Moines and Colorado Springs in the Western League. His last coaching position was in Des Moines with the Drake University Bulldogs. (Courtesy of Jeanne Mitchell-Grisolano.)

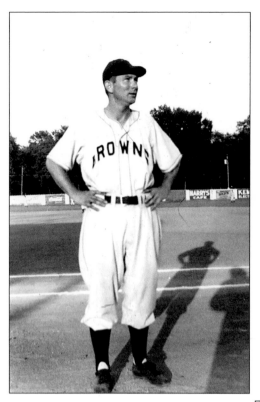

Don Smith took over as manager of the 1948 Pittsburg Browns in late July. The local Pittsburg press was excited about his arrival since he had some impressive playing experience in the Pacific Coast and Texas leagues in 1945 and 1947. His career had started during WW II when he played for Elmira, New York in the Eastern League. Smith, however, was taking over the Pittsburg job after leaving the Ardmore Rockets of the Sooner State League a week earlier. Jimmy Cooke, who had played left field for the Miami Blues in 1946, replaced Smith. Cooke played a lot of baseball in the military with Phil Rizzuto and many of his personal photos with the Yankee shortstop found their way into the KOM League photo collection after his death. (Courtesy of Jeanne Mitchell-Grisolano.)

Al Pilarcik was signed out of Whiting Indiana High School and assigned to the Independence Yankees in 1948. He arrived in town and fell in love with the people, especially the Don Day family. He told this author that the most fun he ever had playing the game of baseball was in the KOM League. He had plenty of chances to judge minor league cities prior to embarking upon a six-year big league career. On his way to the top he played at Joplin, Beaumont, Muskegon, Quincy, Birmingham and Columbus, Ohio. His time in the majors was spent in the American League with Baltimore, Chicago, and Kansas City. (Courtesy of Paul Nichols.)

John William Hall was a member of the 1948 Ponca City Dodgers and participated in a game at Carthage that season which his namesake, the author, so wanted to attend. I had no knowledge of his namesake. The desire I had to attend was due to an appearance by George "Gabby" Street. Street was at that time the sidekick on the St. Louis Cardinal broadcasts with Harry Caray. My uncle had promised to pick him up after he got off work to go see the "Old Sarge." Well, since my uncle was in the commercial air-conditioning business, work never ended that night and I never got to that game. I was heartbroken. Nearly a half-century later, during research of the game that was played the night Gabby Street came to Carthage, it was discovered John Hall was there. It wasn't the 9 year-old kid who lived on Valley Street in Carthage but the 21 year-old right-hander from Cartoga, Costa Rica. Over the years my namesake and I have relived that night. The thing he remembers is winning that contest but never realized he was performing in front of Mr. Street. (Courtesy of Bob Dellinger.)

For two seasons KOM League batters knew Ed "Lefty" Grove as a "crafty little lefty." Those who worked the booths at carnivals that featured throwing contests knew the young man from Lansing, Michigan as something else. If there were items to knock down, Grove could do it in the minimum number of throws. As the late Bob Dellinger recalls, "He never missed and he won so many teddy bears he would be forced to cease playing." (Courtesy of Bob Dellinger.)

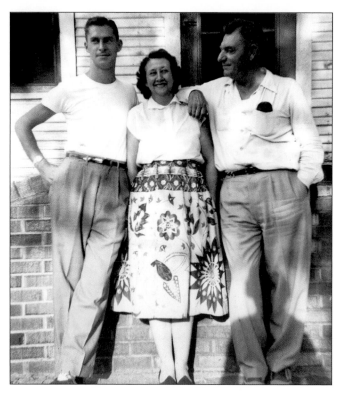

One of the most beloved of all families who housed KOM League ballplayers was Loretta and Bob Mitchell of Pittsburg, Kansas. Here Loretta is shown between Carlton Post on the left and her husband on the right. Her daughter Jeanne Mitchell-Grisolano remarked that her mother had only one hand but it didn't affect her ability to do whatever she had to do. After the Mitchell's were killed in a car wreck, Jeanne was conversing with some of the former Pittsburg Browns players and the topic of her mother having only one hand came up. She said that not a former player with whom she spoke realized her mother had only the one hand. (Courtesy of Jeanne Mitchell-Grisolano.)

Hal Brydle on left and Bob Nichols on the right, both members of the 1948 Iola Indians, let another fellow into this photo taken in early 1949. This is the only snapshot ever located of Bill Upton. Upton was a member of the 1949 Iola Indians and the only person from the Iola KOM League entry to ever make it to the major leagues. The Esther, Missouri native got into two games with the 1954 Philadelphia Athletics. His older brother, Tom, spent a couple of seasons with the St. Louis Browns in 1951 and '52 and a handful of games with the Washington Senators in 1953. (Courtesy of Hal Brydle.)

Young men from the far away big cities were fond of the culture they found in the Midwest. Sonny Catalano (left) of Lindenhurst, Long Island, New York and Charles Stock of Chicago strap on the pistols, don the cowboy hat and try out their first pair of cowboys boots during their season at Bartlesville, Oklahoma. Catalano stayed part of the 1949 season in Bartlesville before moving along to another Class D club. He ended his career at Pulaski, Virginia in the Blue Ridge League in 1950. Stock caught three years in the KOM League before heading into semi-pro baseball in Southern Minnesota. (Courtesy of Trusten Scotten.)

When Art Priebe arrived in the KOM League it was with the fanfare that he was another Marty Marion. The Milwaukee native had started his career in 1942 with Wisconsin Rapids of the Wisconsin State League. Like many aspiring ball players of that era, World War II dashed a lot of dreams. After three years in the service Priebe came back to play for the Topeka, Kansas Owls in 1946 and 1947 and then spent a lot of time standing in water at the Miami Owls baseball facility, waiting a chance to get his team back on a dry field.

49

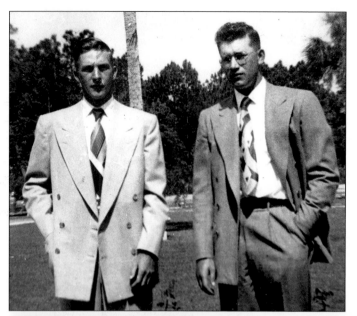

Maybe it is only in the eye of this author but the fellow on the left looks a lot like current day movie star and star of some baseball films, Kevin Costner. He is Bob Yuhas, and on his right his teammate and fellow mounds man, Hal Brydle. Brydle was one of the finest fielding pitchers in the KOM League. In 1949 he pitched in 27 games and had 48 chances without an error. Larry Jaros at Chanute that year had 44 chances without an error in 34 contests. (Courtesy of Hal Brydle.)

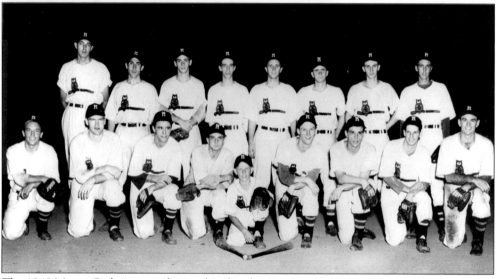

The 1948 Miami Owls "returned to pack" after dominating the league in 1947. The acquisition of Bernie Tye "livened" things up for the Miami club, especially when umpire Bill Mohs worked their games. With a last name of Mohs that sounded too much like "moles," the players called him "Blind Moles." Moles have the characteristic of piling up dirt. In one confrontation with Mohs, Tye didn't appreciate a called strike and started piling dirt on home plate. The madder he got the higher the pile became. Tye swore it was a nine-inch mound before Mohs tossed him from the game. As Tye was headed to the dugout Mohs was screaming at him to come back and clean off the plate. Tye kept going to the dugout since he knew after he was chased from the game the umpire had no more say over his activities. The Owls, pictured here from left to right, are (front row) Jim Price, Jim Hansen, Ray Mazzucco, Tom Tarascio, Gene Hawk (batboy), Rudy Newmann, Jimmy Reaugh, Les Harris, and Guerney Freeman; (back row) Bernie Tye, Warren Liston, Jim Manuel, Ed Wilson, Gene Jaroch, Tom Kappele, Ed Kubabek, and Alex Grieves. (Courtesy of Jim Hansen.)

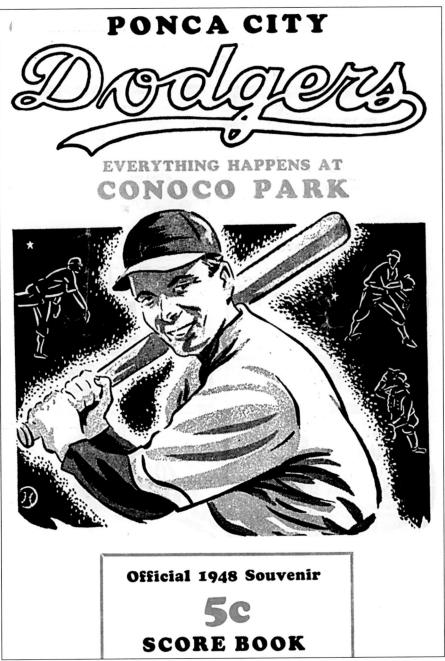

# PONCA CITY
## Dodgers
### EVERYTHING HAPPENS AT
### CONOCO PARK

**Official 1948 Souvenir**

**5c**

**SCORE BOOK**

This 1948 Souvenir scorebook was prepared for a game between the Carthage Cardinals and the hometown Dodgers. It carried all the 1948 leaders in statistics—from Loren Packard's one point lead over Dixie Upright in the batting race to Jim Baxes' 20 home runs and Red Dial's 22 victories. All were records up to that time. One of the more amazing statistics was Loren Packard's 123 RBIs in 120 games. Ponca City was one of the 25 farm clubs in the Brooklyn Dodger system in 1948. There were nine Class D teams either owned by the Brooklyn club or with working agreements. Ponca City fell under the category of "Ownership clubs." (Courtesy of Bob Dellinger.)

E. L. DALE, PRESIDENT
CARTHAGE, MO.

EARL SIFERS, VICE-PRESIDENT
IOLA, KAN.

ARTHUR MOORMAN, SEC.-TREAS.
CARTHAGE, MO.

# KANSAS-OKLAHOMA-MISSOURI
## L    E    A    G    U    E
### ══════ K-O-M ══════

CHANUTE, KANSAS
INDEPENDENCE, KANSAS
IOLA, KANSAS
PITTSBURG, KANSAS
BARTLESVILLE, OKLAHOMA
MIAMI, OKLAHOMA
PONCA CITY, OKLAHOMA
CARTHAGE, MISSOURI

Oct 10 1948

Mr Lee Newman Pres.
Carthage Baseball Assn Inc.
Carthage, Mo.

Dear Lee:
        Subject to approval by two-thirds vote by
the Board of Directors of the K-O-M League, I am proposing
that we hold our annual meeting at lo A.M. Sunday 6th at
the Tioga Inn Chanute Kansas. We have held our annual meeting
the first Sunday in November since formation of the league.
It gives new officers chance to begin preparations for the
coming year and also make arrangements to attend the Minor League
meeting the first week in December.
        If you approve of Chanute as the meeting place Etc. Please
wire me immediately and I will get out formal notice to all
clubs.

                                Sincerely yours

                                E L. Dale

At the conclusion of the 1948 season, the league was looking forward to the 1949 campaign and as history would bear out, it was something special to anticipate. The league was strong and would become even more so in 1949. There was no war on the horizon, television was still in its infancy, and nothing seemed to be able to take the minds of small town America off the game of baseball. (Courtesy of the Reuel King family.)

# FOUR

# The 1949 Season

## *The Season of "The Stars"*

Real money was up-for-grabs in 1949. The average salary of a KOM League ballplayer was a few cents under $150 per month. That year Humphrey Bogart made $467,361 and Ronald Reagan received a "modest" $169,000 as an actor. Harry Truman had to settle for $75,000 a year along with listening to Margaret trying to sing. He married her off to Clifton Daniel so the newspaperman could have the privilege of enjoying Margaret's "melodious" lyrics.

Harry signed the minimum wage act that raised the level to 74 cents from 40 cents.

The world was still reeling from the effects of WW II. The Allies organized NATO and the Blockade of Berlin ended in May. Tokyo Rose was tried and convicted. She was given 10 years and a $10,000 fine for her role in the Japanese campaign to get American soldiers to surrender.

Meanwhile, the United States was stepping up its Cold War efforts. In November it was announced that atomic tests would be conducted at Eniwetok Atoll in the Pacific. A young catcher for the Independence Yankees that year didn't realize that announcement would have particular meaning to a young seaman. Bobby Gene Newbill was a witness to the atomic tests at Eniwetok a couple of years later.

It didn't take long before the world heard of Russia's announcement for the development of an atomic bomb. George Orwell was taking all this in and wrote a new book about the grim world he foresaw, *1984*.

The world survived 1984 but for many it all came to an end in 1949. Bill "Bojangles" Robinson died and with his passing went one of the great tap-dancers in history. An earthquake hit four cities in Ecuador and over 4,600 lives were lost. The greatest ship disaster since the sinking of the Titanic also happened in 1949, when Canadian Luxury Liner, Noronic, went down. A plane crash occurred in the Azores and French boxer, Marcel Cerdan was one of the victims. In other aeronautical news, the Bell X-1 Rocket soared to an altitude of 63,000 feet while in the annual Army-Navy game the Cadets soared past the Midshipmen 38-0 in the biggest rout in the series history to that time.

The world of entertainment was introduced to the little record called the 45-RPM. RCA pioneered it and many recording artists profited greatly by the invention. Frank Sinatra turned 33 and sold tons of those donut shaped records and was still "The Idol of Bobby-soxers." On the Silver Screen Ingrid Bergman was starring in "Joan of Arc" while admitting, "I'm no angel."

The year in sports got off to a rousing flourish as Northwestern beat the University of California in the Rose Bowl. Joe Louis retired as heavyweight champion on March 1. Sam Snead won the Masters Golf Tournament and the baseball world watched as the Yankees and Dodgers met for the World Series. The stars of 1949 were Ralph Kiner, Joe DiMaggio, Ted Williams, Stan Musial and Jackie Robinson. Jackie became the first African American ever to win the Most Valuable Player Award.

With Joe Louis on the retired list, Ezzard Charles defeated Jersey Joe Wolcott for the World Heavyweight title on June 22. Ten days prior to that a 5-foot-10, 160-pound shortstop from the Baxter Springs, Kansas Whiz Kids had been signed by the New York Yankees and played his first professional ball game at Chanute, Kansas for the Independence Yankees. (Of course, that was Mickey Mantle).

The world was in turmoil in 1949 and the KOM League had its own share of the same called, the Miami Owls. When E.L. Dale wasn't handing out fines to the club for "misconduct detrimental to baseball" there was infighting that led to fines, suspensions, and a whole lot of humorous stories.

The class of the league was the Independence Yankees, Bartlesville Pirates and Iola Indians. At the end, only a game-and-half separated those clubs. An all-star team compiled from the KOM League that year could probably win the American and or National League pennants today by about a dozen games. To support this reasoning, a study of the rosters of the teams for 1949 would prove it. Just call me a DIEHARD!!!

## SUMMARY OF KOM LEAGUE DATA FOR 1949

| Team Standings | Won | Lost | Pct. | GB |
|---|---|---|---|---|
| Independence Yankees | 71 | 53 | .573 | — |
| Bartlesville Pirates | 71 | 55 | .563 | 1 |
| Iola Indians | 70 | 55 | .560 | 1.5 |
| Ponca City Dodgers | 66 | 59 | .528 | 5.5 |
| Chanute Athletics | 65 | 60 | .520 | 6.5 |
| Carthage Cubs | 62 | 64 | .492 | 10 |
| Miami Owls | 56 | 69 | .448 | 15.5 |
| Pittsburg Browns | 39 | 85 | .315 | 32 |

*Independence beat Iola 3 games to 0, to win the playoffs. This represented Mickey Mantle's first championship as a professional.*

### LEAGUE LEADERS

#### BATTING
Average: .317, Dick Drury, Bartlesville Pirates
Home runs: 14, Bob Speake, Carthage Cubs
RBI: 95, Jim Bello (aka Belotti), Independence Yankees
Stolen bases: 49, Bobby Bonebrake Ponca City Dodgers. (There were three young men with the name of Bob Bonebrake playing minor league baseball in 1949 and none were kin to the other.)

#### PITCHING
ERA: 1.69, Conrad Swensson, Ponca City Dodgers.
Wins: 18-6, Vernon Vernon "Jake" Thies, Chanute Giants
Strikeouts: 240, Robert Wiesler, Independence Yankees
Shutouts: 4, Jake Thies, Chanute

#### ATTENDANCE
Bartlesville: 51,000
Carthage: 38,028
Chanute: 39,228
Iola: 49,491
Independence: 46,607
Miami: 32,887
Pittsburg: 46,607
Ponca City: 62,082

**PLAYERS FROM 1949 KOM LEAGUE TEAMS WHO MADE IT TO THE MAJOR LEAGUES**
Independence: Robert Wiesler, Steve Kraly, Lou Skizas and Mickey Mantle
Bartlesville; Edward Wolfe
Chanute: Vernon "Jake" Thies
Iola: William Ray Upton (His older brother Tommy played for the Washington Senators.)
Miami: Harry James Bright
Carthage: Robert Speake

**MANAGERS IN THE KOM LEAGUE IN 1949 WITH PREVIOUS MAJOR LEAGUE EXPERIENCE**
Ponca City: Boyd Bartley
Independence: Harry Craft and Burleigh Grimes (interim)
Chanute: Charles Bates
Bartlesville: Tedd Gullic

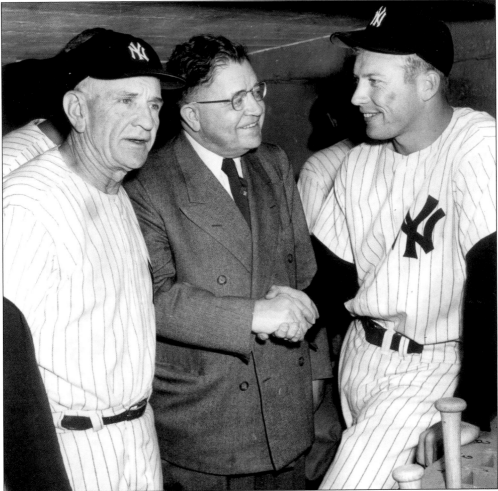

Some stars were born on the fields of the KOM League in 1949 but not many fans, players or managers recognized them in their infancy. Mickey Mantle started very slowly and eventually made a run at the batting title. In 1953 former KOM League President, E.L. Dale was guest in the Yankee dugout. Mr. Dale (center) shakes the hand of the "slow starter" who became the most successful KOM League graduate as Casey Stengel looks on. (Courtesy of Robert Dale.)

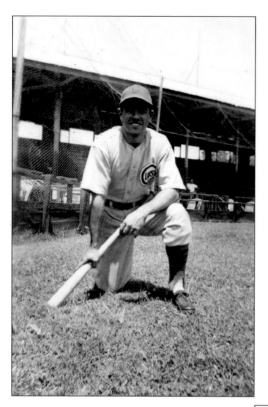

The 1949 Carthage Cubs were unique in having two players who had previous major league experience. The experience, however, was in the batboy realm. Johnny LaPorta, a Chicago boy, had been the "lumber hauler" for the Cubs from 1941 to 1943. He got the job after his older brother relinquished it after serving from 1939 to 1941. LaPorta had two years of minor league experience by the time he joined Carthage in 1949. He played again briefly for Carthage in 1950 and concluded his career in 1951 at Rock Hill, North Carolina in the Tri-State League. (Courtesy of Angela LaPorta.)

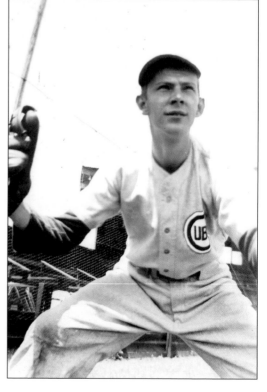

The other former Major League batboy to appear on the scene at Carthage in 1949 was Ed Garrett of Cincinnati, Ohio. He served as the Reds batboy from 1943 to 1946. Garrett was a very good pitcher and he was a member of the American Legion championship team in 1947. He was a close friend to two young men in the neighborhood named Zimmer. Hal Zimmer later played in the Dodger chain at Ponca City in the KOM League and his brother, Don, played, managed and coached in the major leagues over a half-century. (Courtesy of Phil Costa.)

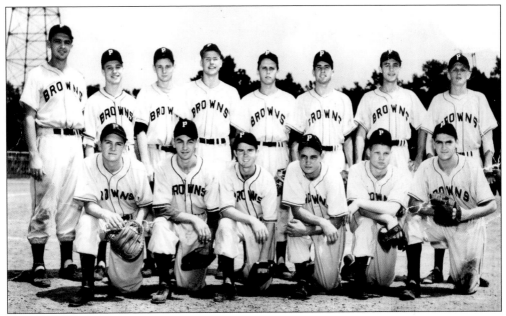

The 1949 Pittsburg Browns were one of those clubs that were said to have one team coming, one going, and one on the field. In other words there was a lot of personnel turnover. The Pittsburg photographer stopped the following fourteen fellows long enough to get a team photo. They are, from left to right (front row) Bob Glaze, Sal Nardello, Jim McHugh, Emil Jurcic, Bill McCormick, and Bob Jenkins; (back row) Olan Smith, Jim Waugh, Jim Stevens, Joe Lyles, Loren Stewart, Don Irland, Jack Chatham, and Lou Novak. (Courtesy of Don Irland.)

Phil Costa and Bob Saban were "fresh" off the Carthage Cub bus for a road game in 1949. Costa was raised in the same neighborhood where Al Capone lived when he ruled Chicago. Saban's

full name is Matthew Leroy Robert and was a Chicago Cub signee from McCook, Illinois. Saban was injured in his first starting assignment in 1949 when he attempted to catch a line drive hit back to the mound, with his bare hand. Manager Don Anderson claimed that with a healthy Saban the Carthage Cubs, not the Independence Yankees, would have been the KOM League champions in 1949. (Courtesy of Phil Costa.)

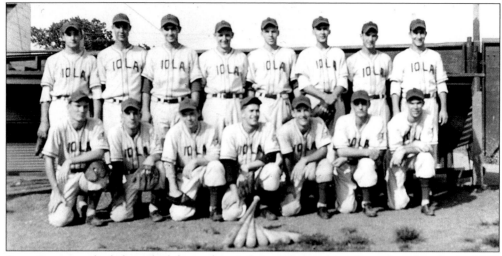

Sometimes everybody has a bad day and can't focus. That is the only explanation for the 1949 Iola Indian team photo. There were large and small photos taken of the team posing and everyone was just a "tad" blurry. However, when searching the history of a league that has been extinct for over a half-century, sometimes second best is all that can be hoped for regarding photos. In that vein, Iola was the second place finisher. This picture was taken August 20, 1949 and represents a roster that was intact for the entire season. Some teams had roster turnover that involved up to 60 players a year. This team had a total of 21. The 15 around at the close of the season, pictured from left to right, are (front row) Ed Scott, Gene Daily, Lou Ott, Hal Brydle, Dick Fought, Windy Johnson, and Bill Upton; (back row) Ken Geer, Joe Malott, Al Dunterman, George Boselo, Bill Anderson, Bob Nichols, Benny Leonard, and Dick Getter.

James J. McHugh, a native of Philadelphia, played in more games (431) than anyone in KOM League history. He started his career with the 1949 Pittsburg Browns and then spent 1950, 1951 and most of 1952 with the Miami Eagles. He concluded his career with Granby, Quebec in the Canadian-American League in 1953. (Courtesy of Jeanne Mitchell-Grisolano.)

Robert A. Roman had a 21-game season in 1948 at St. Augustine in the Florida State League and fell one game short of duplicating that with the Carthage Cubs in 1949. When the early June roster cuts rolled around the Syracuse, New York native returned home and worked as a retail salesman. He had an interest in music and sang in some small productions in his hometown. Roman had a great baritone voice and was encouraged to go to New York for tryouts for the Broadway stage, which landed him a new career. He also performed on Broadway traveling shows around the United States until getting into the automobile business in Durham, North Carolina, where he died on Christmas Eve of 1996. (Courtesy of Mona Roman.)

Robert Roman poses in front of the Carthage scoreboard in early May of 1949. By the time the June deadline came for trimming the 18-man rosters down to 15, Roman became a casualty of the numbers game. (Courtesy of Woody Wuethrich.)

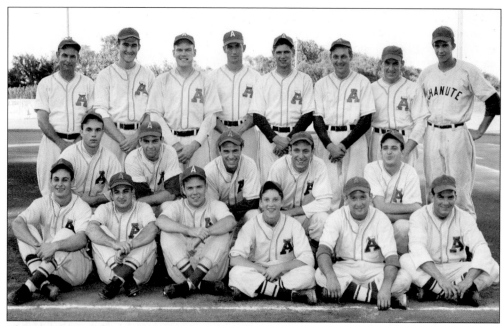

This club posted the last winning record in Chanute baseball history, going 65-60. They had the top winner in right-hander Jake Thies, the top defensive catcher in Jim Hansen, and the second leading hitter in shortstop Kent Pflasterer. Pflasterer beat out another shortstop, Mickey Mantle, .314 to .312. The 1949 Chanute Athletics, pictured from left to right, are (front row) Kent Pflasterer, Tom Tarascio, Tom Norbut, John Fehr-Batboy, Roy Coulter, Jim Imbeau, and Jack Butler; (middle row) Pete New, Jim Marks, Ray Mazzucco, Tom Imfeld, and Al Fadell; (back row) Charlie Bates, Ed Morganthaler, Jim Hansen, Al Stewart, Larry Jaros, Jake Thies, Dave Dennis, and Dave Newkirk. (Courtesy of Jim Hansen.)

# Independence Yankees 1949 Schedule

| GAMES AT HOME | | GAMES AWAY | |
|---|---|---|---|
| May 5, 6, 7 | Iola | May (8), 9, 10 | Ponca City |
| May 14, (15), 16 | Carthage | May 11, 12, 13 | Bartlesville |
| May 20, 21, (22) | Pittsburg | May 17, 18, 19 | Miami |
| May 23, 24, 25 | Chanute | May 26, 27, 28 | Iola |
| May (29), 30* | Ponca City | June 3, 4, (5) | Carthage |
| May 31, June 1, 2 | Bartlesville | June 9, 10, 11 | Pittsburg |
| June 6, 7, 8 | Miami | June (12), 13, 14 | Chanute |
| June 15, 16, 17 | Iola | June 18, (19), 20 | Ponca City |
| June 24, 25, (26) | Carthage | June 21, 22, 23 | Bartlesville |
| June 30, July 1, 2 | Pittsburg | June 27, 28, 29 | Miami |
| July (3), 4* | Chanute | July 5, 6, 7 | Iola |
| July 8, 9, (10) | Ponca City | July 15, 16, (17) | Carthage |
| July 12, 13, 14 | Bartlesville | July 21, 22, 23 | Pittsburg |
| July 18, 19, 20 | Miami | July (24), 25, 26 | Chanute |
| July 27, 28, 29 | Iola | July 30, (31), Aug. 1 | Ponca City |
| Aug. 5, 6, (7) | Carthage | Aug. 2, 3, 4 | Bartlesville |
| Aug. 11, 12, 13 | Pittsburg | Aug. 8, 9, 10 | Miami |
| Aug. (14), 15, 16 | Chanute | Aug. 17, 18, 19 | Iola |
| Aug. 20, (21), 22 | Ponca City | Aug. 26, 27, (28) | Carthage |
| Aug. 23, 24, 25 | Bartlesville | Sept. 1, 2, 3 | Pittsburg |
| Aug. 29, 30, 31 | Miami | Sept. (4), 5* | Chanute |

Games at Riverside Stadium,
Independence, Kansas

( ) Sunday Games
* Holiday Doubleheaders

**Follow the YANKS on the Diamond and in THE REPORTER**

This 1949 Independence schedule provided the fans all the information they needed to follow their team at home and on the road. (Courtesy of Rosie Baldrick-Day.)

Conrad Swensson, a native of McPherson, Kansas, was one of the most successful hurlers in KOM League history. The lefty developed a knuckle-curve that saw him post a 12-3 record in 1949 with the all-time league low ERA of 1.69. That kind of record should have propelled Swensson through the Dodger organization, but didn't. He returned to Ponca City in 1950 and posted a 16-3 mark. He was shuffled off to Newport News, Virginia in the Piedmont League in 1951 and then to Hornell, New York in the PONY League. After a few more stops in the Pioneer and Texas leagues, the St. Louis Browns signed Swensson in 1954. That is when he said "no" to baseball and hung up the spikes. In another era his impact on baseball would have been a lot greater. (Courtesy of Bob Dellinger.)

Don Anderson managed the Carthage Cubs from 1949 until July 9, 1951. On July 2, 1951, he left his batboy at the Pittsburg, Kansas ballpark. That incident remained vivid in that former batboy's mind until he did something about it in 1994. He began writing his memories of that old league, both the good and bad. A couple of years later Anderson made contact with the batboy and apologized for his transgression made innocently 43 years earlier. Anderson proposed a dinner engagement and flew from Hemet, California to Columbia, Missouri to "make things right." Since that day, Anderson and the batboy have become the best of friends. I am happy to say we both lived long enough to swap stories of the KOM League and to listen to Anderson's tales that go back to the Northern League of 1939. (Courtesy of Don Anderson.)

This is a rare photo from the KOM League era since it depicts an action shot, even though taken during infield practice. The shortstop is Sal Nardello, and the pivot man on the play is Jim McHugh. (Courtesy of Jeanne Mitchell-Grisolano.)

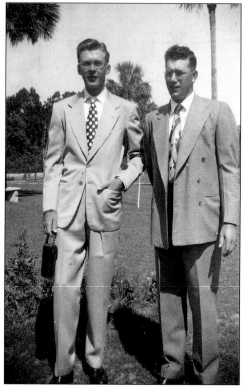

Seldom did anyone see KOM League ballplayers wearing suits. That will explain how Bob Nichols (left) and Hal Brydle have appeared so often in this book. Nichols and Brydle were both Ohio natives who had been inked to Cleveland Indian minor league contracts. Nichols was a Canton native and Brydle was born in Conneaut, Ohio. Nichols was Brydle's senior by four years and entered baseball three years after he was released from the United States Army. Each of this pair saw action in both 1948 and 1949 with the Iola Indians. (Courtesy of Hal Brydle.)

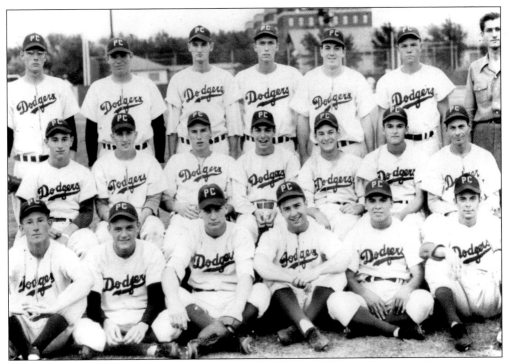

(*above*) The 1949 Ponca City Dodgers included, from left to right, are (front row) John Mamerow, Louis Hula, Loren Doll, Nick Zender, Jim Carney, and Ed Grove; (middle row) Bob Beran, Wally Dunford, Richard Hames, Bob Bonebrake, Don Keeter, Gene Castiglione, and Boyd Bartley (manager); (back row) Dick Tretter, Dave Williams, Dick McCoy, Ernie Nichols, Jack Nixon, Richard Loeser, and Jack Lewis (business manager). At a time the Brooklyn Dodger organization was noted for its speed, the fastest man in the organization was Jim Carney. (Courtesy of Dick McCoy.)

(*right*) Dick Tretter (back row, far left, above) of the 1949 Ponca City team gave up baseball for acting. He performed for many years on the stage, television and in big production movies. His credits include the television series *Combat* and *The Millionaire*. He also played in the last *Lassie* trilogy. He rejects any attempts at calling him a movie star for he claims he was only an actor and never approached stardom. (Courtesy of Dick Tretter.)

63

This is probably the most coveted of all KOM League photos since it is the first professional team photo in which Mickey Mantle appeared. The 1949 Independence Yankees, from left to right with primary position(s) indicated, are (front row) Jim Bello (OF), Steve Kraly (P), Charlie Weber (Inf./OF), Ken Bennett (P), Bill Chambers (OF), Jack Whitaker (C), Lou Skizas (3B), and Mickey Mantle (SS); (back row) John Cimino (OF), Bob Mallon (P), Joe Crowder (P), Keith Speck (P), Harry Craft (Mgr.), Bob Wiesler (P), Bobby Gene Newbill (C), Nick Ananias (LB), and Al Long (P). From this group, Steve Kraly, Lou Skizas, Mickey Mantle and Bob Wiesler all performed in the major leagues. Manager Harry Craft had played center field for the Cincinnati Reds and was in the lineup during Johnny Vander Meer's consecutive no-hitters. (Courtesy of Bob Wiesler.)

Ballplayers of the KOM League era didn't have much experience with "refrigerated air." The most popular fans of the KOM League were of the electrical variety. Players used to soak their sheets in cold water from the showers and then throw them on the bed or take their mattresses to the top of the hotel and sleep on the roof. They usually found out the next day that the mattresses had become permanent fixtures, since the hot tar on the roof did not want to give up its prey. (Courtesy of Dean Manns.)

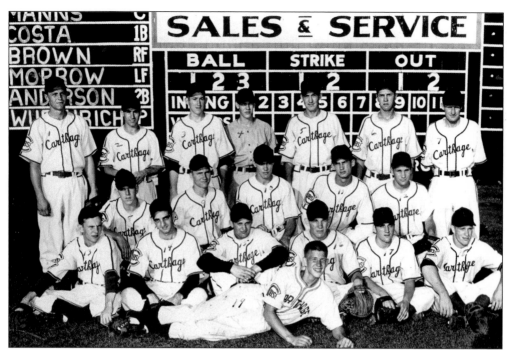

The 1951 club, pictured from left to right, included (front row) Paul Hoffmeister, Ed Garrett, Woody Wuethrich, Phil Costa, Bob Speake, and Art Leslie; (middle row) Hal Brown, Dean Manns, Darrell Lorrance, Denny Moffitt, and Hank Paskiewicz; (back row) Glen Walden, Don Schmitt, John LaPorta, Bob Saban, Alan Burger, Frank Morrow, and Don Anderson (manager). The young man on the ground was batboy, Harry Smith. This team had one player, Bob Speake, who went to the Major Leagues, first with the Chicago Cubs and then with the San Francisco Giants. (Courtesy of Woody Wuethrich.)

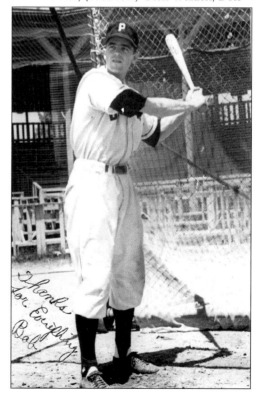

There weren't a lot of good on-the-field memories for the 1949 Pittsburg Browns. A 39-84 record will ensure that. Bob Glaze was a member of the club for 72 games and probably that many meals at the Loretta and Bob Mitchell home. When he got his individual photo, the California native gave it to the Mitchells with the message, "Thanks for everything." (Courtesy of Jeanne Mitchell-Grisolano.)

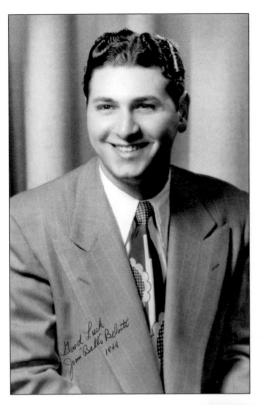

Some guys were known by one name in one league and by another whenever they went elsewhere. Jim Belotti was a 15-year-old performer in 1945, using his real name with Springfield in the Ohio State League. He didn't play in 1946 or 1947 but was on the roster of Carbondale, Pennsylvania in 1946 and Federalsburg and Port Chester, Pennsylvania in 1947. In 1948 he continued his career as Jim Bello with Mayfield, Kentucky of the Kitty League, and Wausau, in the Wisconsin State League. He stayed with the shortened version of his name in 1949 first with Greenville, Mississippi of Cotton States League and after he was sent to Independence, Kansas where he played in enough games to win the RBI title with 95. He felt he should have been given a chance to join many of his 1949 Independence teammates at Joplin in 1950, but was instead sent to the Gulf Coast League. After a couple of years in the Army, Belotti returned to play through 1955 in the Longhorn and Georgia-Florida leagues. Just to ensure he covered all bases, he signed both of his baseball last names on the photo. (Courtesy of Jim Belotti.)

It wouldn't be too difficult to assert John Waltman may have been the best hurler in the KOM League in 1949. He posted a 16-14 record for a club that only won 39 contests. He threw more innings (253) than anyone else by a wide margin. His ERA was 2.42 and he allowed just 39 walks while striking out 149. His control was exemplified by the fact he only had one wild pitch the entire season. The Ellerslie, Maryland native played in the Browns organization until being drafted into the Army in 1953. By that time he was with San Antonio of the Texas League. He played for the Brooke Army Medical Center team during his time in the military. (Courtesy of Jeanne-Mitchell Grisolano.)

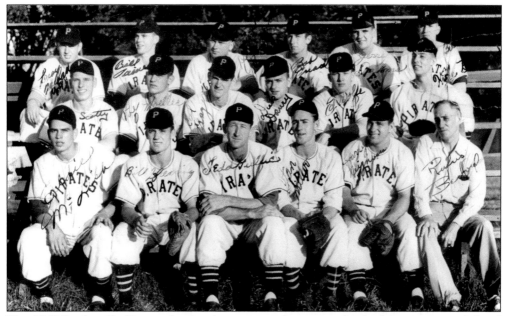

The 1949 Bartlesville Pirates, despite the amount of turnover, finished just one game behind the Independence Yankees for the pennant. Managed by former St. Louis Brownie, Tedd Gullic, the Pirates managed to win despite his avowed dislike of players from California. He still wound up with half of his roster being populated by the boys from the West Coast. The fellows in this late season photo, from left to right, are (front row) Ed McLish, Bill Herring, Ted Guillic, Stan Miller, Harry Neighbors, and Rufus Bedford (business manager); (middle row) Trusten Scotten, Rolf Moeller, Cal Frazer, Dick Drury, Ed Wolfe, and Kyle Bowers; (back Row) Leroy Mehan, Bill Paine, Dean Jongewaard, Bob Pinard, Jerry Dahms, and Bob Wheeler. Dick Drury led the league in hitting that year, nosing out Kent Pflasterer and Mickey Mantle by .003 and .004, respectively. One of the hurlers on that team had a brother with the Chicago Cubs at the time. The brother had longest name of anyone ever to play the game. It was Calvin Coolidge Julius Caesar Tuskahoma McLish. For short, they called him "Buster." Ed Wolfe, a pitcher for this team, also had a brief stint in the big leagues with the Pittsburgh Pirates in 1952. (Courtesy of Trusten Scotten.)

| INDEPENDENCE | | 1 | 2 | 3 | 4 | 5 | 6 | 7 | 8 | 9 | 10 | R | H | E |
|---|---|---|---|---|---|---|---|---|---|---|---|---|---|---|
| 15 WIESNER LF | | | | | | | | | | | | | | |
| 23 WEBER 2B | 302 | | | | | | | | | | | | | |
| 12 SKIZAS 3B | 318 | | | | | | | | | | | | | |
| 21 BELLO RF | 305 | | | | | | | | | | | | | |
| 18 ANANIAS 1B | 304 | | | | | | | | | | | | | |
| 7 CIMINO CF | 237 | | | | | | | | | | | | | |
| 16 MANTLE SS | 315 | | | | | | | | | | | | | |
| 24 WHITAKER C | 246 | | | | | | | | | | | | | |
| 5 BENNETT P 12 3 | | | | | | | | | | | | | | |

This scorecard is one of two known to exist that shows Mickey Mantle playing in a KOM League game. The card was not kept for that reason but due to the fact Dick Getter was playing for the opposing Iola club. Getter's father-in-law did the scoring of this game. (Courtesy of Dick Getter.)

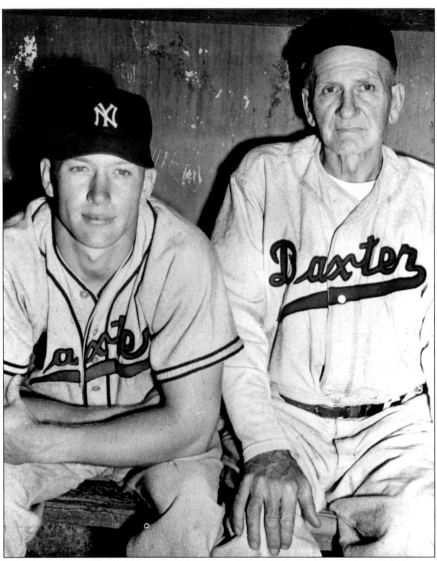

This is the last photo taken of Mickey Mantle and his boyhood Baxter Springs, Kansas Whiz Kid coach, Walter A. "Barney" Barnett. The Sunday following the last game of the 1952 World Series, Barnett had arranged for a game at Miners Park in Joplin between the Mickey Mantle and Cloyd Boyer All-Stars. The game attracted some of the best baseball players from around the area and the pitchers for the Boyer All-Stars accomplished in that game what the Dodgers couldn't do in the World Series—hold Mantle in check. The game drew 5,000 fans and even witnessed Mantle taking the mound in the last inning so that he could "show off" his knuckleball. Gale Wade smacked one of those knucklers against the right field wall and in rounding second base turned his ankle and pretty much sealed his hopes of a long major league career. In this photo Mantle is wearing the 1952 version of the Whiz Kid uniform along with the cap he had worn during the World Series. Less than a month later, Mantle and Barnett were together for the last time. Mantle was in the First Baptist Church, sobbing like a child, as the final tributes to Barnett were being paid. The only other known photo of this scene was enlarged, framed and given to Barnett in his last few days. The inscription read, "To Barney, thanks for everything. Mick."(Courtesy of Cas Barnett.)

# FIVE

# The 1950 Season

## *The Clouds of War on the Horizon*

As the 20th Century hit the midway point the KOM League had experienced 71 percent of its total life. The American Armed Forces crossed the 38th Parallel on October 7—the first time since the Korean War began. The North Koreans had done the same thing, going in a southerly direction, on June 25. That action probably had more of a negative impact on the continuance of the KOM League than any other single event.

The world was concerned with "bombs" and "commies" in 1950. Harry Truman ordered the building of the H-bomb while Alger Hiss was sentenced to a 5-year prison term for suspected of being a Communist sympathizer. Truman had a busy year. Between ordering the H-bomb, giving the military the power to wage war on North Korea, calling up the National Guard and asking for Statehood for Alaska and Hawaii, he almost "bought the farm." On November 1, he was fired upon by a group of Puerto Ricans in an assassination attempt.

Budge Patty won the Wimbledon Tennis Tournament and made a bold statement as to why he succeeded, "I won because I gave up smoking." Al Jolson also gave up smoking on October 23. He also gave up eating, and breathing. Edgar Rice Burroughs, who provided jobs for Chita, Jane and the guy swinging on all those vines through the jungle, died in March of that year. Although Edgar died his creation, Tarzan, lives on.

The sports world heralded the accomplishments of Althea Gibson, who became the first black to compete in a sanctioned U.S. Tennis Championship match. Florence Chadwick swam the English Channel in record time while a young man was born in February and was given the name of Mark Spitz. He became a pretty good swimmer in his own right. Ted Williams was gleeful about the prospects of making $125,000 a year but had no way of knowing he would soon be back in the Armed Services.

On October 19, a career that spanned 67 years as a player, manager and club owner came to close. Connie Mack, at age 87 called it quits. Mack proved at least one thing—that a manager's job security is greatly enhanced when he also happens to be the owner.

The world was in a time of great transition, as TV was becoming an entertainment medium instead of a curiosity item. RCA produced the first 3-color picture tube during January and most viewers were watching Milton Berle, Ed Sullivan, Six Gun Playhouse and Wrestling. Those were the hit shows of year. However, they were being watched in black and white. On the other hand, critics were already sounding the alarm that television was getting in the way of schoolbooks.

The nearest television station to any KOM League city was either Kansas City, Missouri or Tulsa, Oklahoma, and the reception in towns such as Carthage left much to the imagination. Two young Carthage boys skipped their classes one afternoon to go to a local electronics store to stand outside and "watch" the Philadelphia Phillies lose to the New York Yankees. In fact, the Phillies went down in four straight games. Had the series gone the full seven games the

youngsters would probably have been expelled, sent to reform school, and one of them would have missed being the batboy for the 1951 Carthage Cubs. Those two boys never got a glimpse of anything but snow and a flickering screen. However, they thought at times they saw Granville Hamner, Del Ennis, Mike Goliat, Andy Seminick and Jim Konstanty. It didn't much matter about the Yankees. We didn't like them at all. They just happened to be there to provide an opponent for a National League team.

The place where Corky Simpson and this author stood that October afternoon, in Carthage, watching the first baseball game on television in our lives, was not more than 100 yards from a historic site. The site was the North Side of the Drake Hotel where, 16 months earlier, Independence Yankee rookies Jack Hasten and Mickey Mantle allegedly went down the fire escape ladder to have a "night on the town."

The KOM League had a race for about half the season. Pittsburg, with fellows like Charlie Locke, Jim Pisoni and Bob Ottesen, ran a good pace to the All-Star break and then proceeded to defeat the All-Stars with great pitching, 6-0. After the All-Star break the Ponca City Dodgers went out and hid from the competition. Dodger Stan Gwinn led the league in hitting at .3199, Willie Davis of Ponca City set a new KOM League record with 21 homers, and Harry Neighbors of Bartlesville knocked in 107 runs.

The top pitchers were Tom Vines of Carthage and Don McKeon of Miami with 17 wins each. Tom Vines, Charlie Locke and Lou Michels all tossed a handful of shutouts.

Ponca City finished the season with a league record of 80 wins and 42 losses. That record stood for one year. Ponca City won 85 times the following season.

The league drew 303,662 fans and used the services of 333 roster players. Iola and Chanute employed 110 players between them and posted a combined 70-173 record.

A good pitcher, Larry Jaros, spent time with both clubs and posted a 7-20 record. He was thus the only 20-game loser in league history.

1950 was the last time the KOM League fielded eight teams. Two years later it was dead and buried. It remained basically forgotten for four decades. Forty-two years later we started digging up the old carcass, revealing how much has been uncovered and how much there is left to discover. So, enjoy this "exhumation" of **1950.**

### SUMMARY OF KOM LEAGUE DATA FOR 1950

| Team Standings | Won | Lost | Pct. | GB |
|---|---|---|---|---|
| Ponca City Dodgers | *80 | 42 | .656 | — |
| Bartlesville Pirates | *73 | 48 | .603 | 6.5 |
| Carthage Cubs | 75 | 50 | .600 | 6.5 |
| Pittsburg Browns | 71 | 52 | .577 | 9.5 |
| Miami Eagles | 62 | 60 | .508 | 18 |
| Independence Yankees | 60 | 66 | .476 | 22 |
| Iola Indians | 35 | 84 | .294 | 43.5 |
| Chanute Athletics | 35 | 89 | .282 | 46 |

*Ponca City defeated Bartlesville three games to 1, to win the playoffs.*

### LEAGUE LEADERS

#### BATTING
Average: .319-Stan Gwinn, Ponca City Dodgers. (He beat out Malcolm "Bunny" Mick, Independence Yankees, by .0001.)
Home runs: 21, Willie Davis, Ponca City Dodgers
RBI: 107, Harold Neighbors, Bartlesville Pirates
Stolen bases: 53, Stan Gwinn.

## PITCHING
ERA: 2.04, Dave Elliott, Bartlesville Pirates
Wins: 17-9, Tom Vines, Carthage Cubs and 17-11, Don McKeon, Miami Eagles
Strikeouts: 234, Tom Vines
Shutouts: 5, Tom Vines; Charlie Locke, Pittsburg Browns; Lou Michels, Independence
Yankees

## ATTENDANCE
Bartlesville: 56,250
Carthage: 29,080
Chanute: 21,372
Iola: 23,782
Miami: 27,548
Pittsburg: 43,953
Independence: 38,274
Ponca City: 63,313

## PLAYERS FROM 1950 KOM LEAGUE TEAMS WHO MADE IT TO THE MAJOR LEAGUES
Pittsburg: Charles Edward Locke and James Pete Pisoni.
Bartlesville: Edward Wolfe and Ronald Lee Kline. (Kline was also a member of the 1951
Bartlesville club.)
Independence: William Charles Virdon, Donald Franklin Taussig and John Richard Gabler
Ponca City: Joe Stanka. (He came back in 1951 as a member of George Scherger's team.)

## MANAGERS IN THE KOM LEAGUE IN 1950 WITH PREVIOUS MAJOR LEAGUE EXPERIENCE
Ponca City: Boyd Bartley
Bartlesville: Tedd Gullic
Miami: Francis "Pug" Griffin and James Oglesby
Chanute: Charles Bates and Charles Hostetler.

There were always two games in town. One was the KOM League version at the ballpark and the other was over radio stations in Carthage, Joplin, Pittsburg and Miami. Many games were blacked-out when the KOM League team was at home, but KDMO radio in Carthage approved having KFSB in Joplin air the St. Louis Cardinals games. That pleased this author, for listening to the Cardinals was almost as good as going out to see the local team. (Courtesy of the Reuel King family.)

**ST. LOUIS NATIONAL BASEBALL CLUB, INC.**

January 19, 1950

Mr. L. E. Newman
Carthage Baseball Assn., Inc.
Carthage, Missouri

Dear Mr. Newman:

Thanks very much for your courtesy in giving us permission to have the Cardinal games broadcast in your area. We want you to know that we appreciate it very much and hope that the broadcasts will be beneficial to both of us and to baseball as a whole.

Sincerely yours,

James L. Toomey

JLT/bb

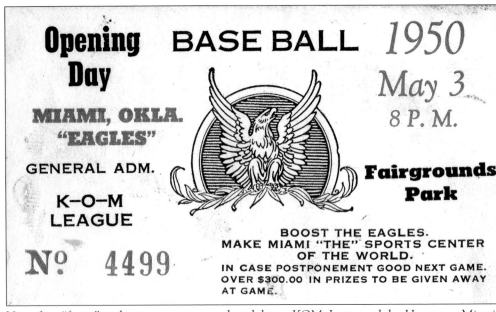

Opening Day
BASE BALL 1950
May 3
8 P. M.

MIAMI, OKLA.
"EAGLES"

GENERAL ADM.

K–O–M LEAGUE

N⁰ 4499

Fairgrounds Park

BOOST THE EAGLES.
MAKE MIAMI "THE" SPORTS CENTER OF THE WORLD.
IN CASE POSTPONEMENT GOOD NEXT GAME.
OVER $300.00 IN PRIZES TO BE GIVEN AWAY AT GAME.

Very few "fancy" tickets were ever produced by a KOM League club. However, Miami, Oklahoma went all out for their home opener in 1950. This was their first year as "The Eagles" and the ticket displayed their emblem in an attractive manner. (Courtesy of Jim McHugh.)

## Carthage CUBS 1950 Playing Schedule

| HOME GAMES | W. | L. | ROAD GAMES | W. | L. |
|---|---|---|---|---|---|
| May 6, (7), 8, Iola | --- | --- | May 3, 4, 5, Miami | --- | --- |
| May 12, 13, (14), Independence | --- | --- | May 9, 10, 11, Pittsburg | --- | --- |
| May (21), 22, 23, Bartlesville | --- | --- | May 15, 16, 17, Chanute | --- | --- |
| May 24, 25, 26, Miami | --- | --- | May 18, 19, 20, Ponca City | --- | --- |
| May 30*, 31, Pittsburg | --- | --- | May 27, (28), 29, Iola | --- | --- |
| June (4), 5, 6, Chanute | --- | --- | June 1, 2, 3, Independence | --- | --- |
| June 7, 8, 9, Ponca City | --- | --- | June 10, (11), 12, Bartlesville | --- | --- |
| June 16, 17, (18), Iola | --- | --- | June 13, 14, 15, Miami | --- | --- |
| June 22, 23, 24, Independence | --- | --- | June 19, 20, 21, Pittsburg | --- | --- |
| July 1, (2), 3, Bartlesville | --- | --- | June (25), 26, 27, Chanute | --- | --- |
| July 4*, 5, Miami | --- | --- | June 28, 29, 30, Ponca City | --- | --- |
| July (9), 10, 11, Pittsburg | --- | --- | July 6, 7, 8, Iola | --- | --- |
| July 17, 18, 19, Chanute | --- | --- | July 14, 15, (16), Independence | --- | --- |
| July 20, 21, 22, Ponca City | --- | --- | July (23), 24, 25, Bartlesville | --- | --- |
| July 29, (30), 31, Iola | --- | --- | July 26, 27, 28, Miami | --- | --- |
| Aug. 4, 5, (6), Independence | --- | --- | Aug. 1, 2, 3, Iola | --- | --- |
| Aug. (13), 14, 15, Bartlesville | --- | --- | Aug. 7, 8, 9, Chanute | --- | --- |
| Aug. 16, 17, 18, Miami | --- | --- | Aug. 10, 11, 12, Ponca City | --- | --- |
| Aug. 22, 23, 24, Pittsburg | --- | --- | Aug. 19, (20), 21, Iola | --- | --- |
| Aug. 28, 29, 30, Chanute | --- | --- | Aug. 25, 26, (27), Independence | --- | --- |
| Aug. 31, Sept. 1, 2, Ponca City | --- | --- | Sept. (3), 4*, Bartlesville | --- | --- |

\* Indicates Holiday doubleheaders.

( ) Indicates Sundays.
Home Games Start _____ 8:15

CARTHAGE PRESS, CARTHAGE, MO.

The Carthage Cubs never printed tickets or scorecards but they were good at handing out pocket schedules. The KOM League started the season in early May and ended on Labor Day. When a team went to the most distant sites in their league they often spent six days on the road, and the only time a team had a day off was when it rained. Some players were known to have left the water hoses run all night on the infield in order to get a game called off. (Courtesy of the Reuel King family.)

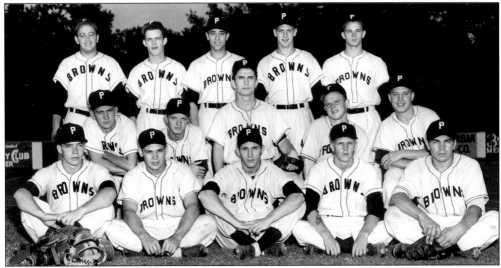

The 1950 season saw the fortunes of baseball turn around drastically in Pittsburg following a disappointing 1949. This club hosted the KOM League All-Stars by virtue of being in first place at mid-season. Two members of this club, Jim Pisoni and Charlie Locke, went to the major leagues. Locke recalled his teammate, John Lazar, who worried all during the 1950 season that the Korean War would heat up and he would be called to serve, and in the process lose his life. Following the 1951 season, Locke returned to his Malden, Missouri home and picked up *The Sporting News*. Under the "Necrology" section there was the name of his teammate who had a premonition of his early death. This club, pictured from left to right, included (front row) Roy Leafgren, Bob Norden, Ed Gustin, Lou Novak, and John Lazar; (middle row) Jack Brown, Cliff Keeley, Charlie Locke, Don Harris, and Jim Waugh; (back row) Stan Bialkowski, Al Keefe, Jim Pisoni, Ray Lindquist, and Bob Ottesen. (Courtesy of Stan Bialkowski.)

Much of the transactions between players and clubs, and the clubs and the official at minor league headquarters, were done by Western Union. In this missive, Allen Burger was very anxious to get back to playing baseball. By the way, he was reinstated. (Courtesy of the Reuel King family.)

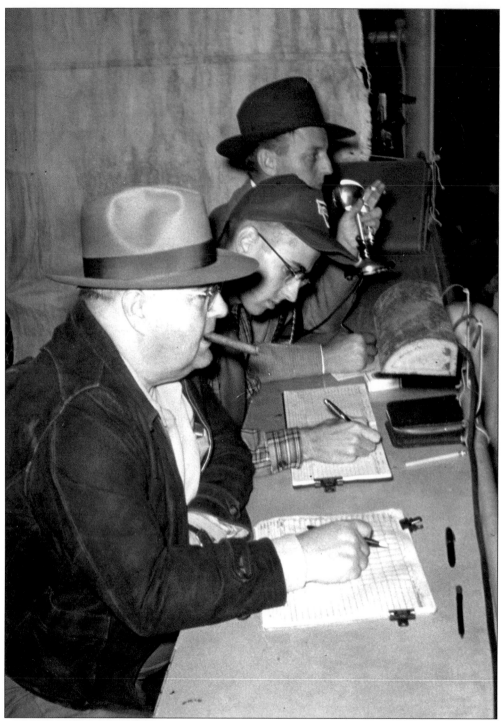

Press boxes of the KOM League usually held three people if there was a place large enough to hold them. Ponca City had some of the better facilities. In the foreground is H.F. "Tubby" Wilber (official scorer), Bob Dellinger (sports writer for the *Ponca City News*) and Everett Black (public address announcer). (Courtesy of Bob Dellinger.)

# PONCA CITY

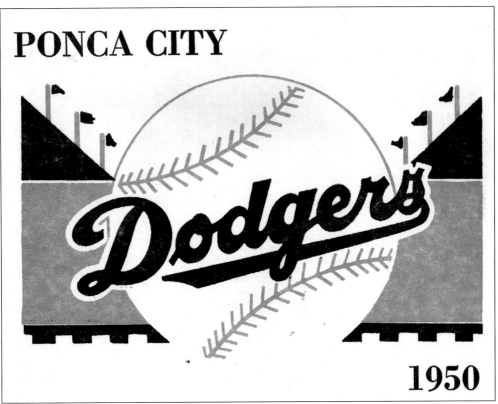

**1950**

The Ponca City Dodgers always put out a great scorecard. They could do so for the town backed the club and the merchants of the city purchased advertising both in the scorecard and on the outfield walls. Those walls at Ponca City were constructed of tank steel. Any ball hit off the wall would make a "pinging" sound. The ballpark was located on the grounds of the Conoco Oil Company, and the odor from the refinery made many a ball player sick. The site of that "Dodger Stadium" is now a parking lot. (Courtesy of Bob Dellinger.)

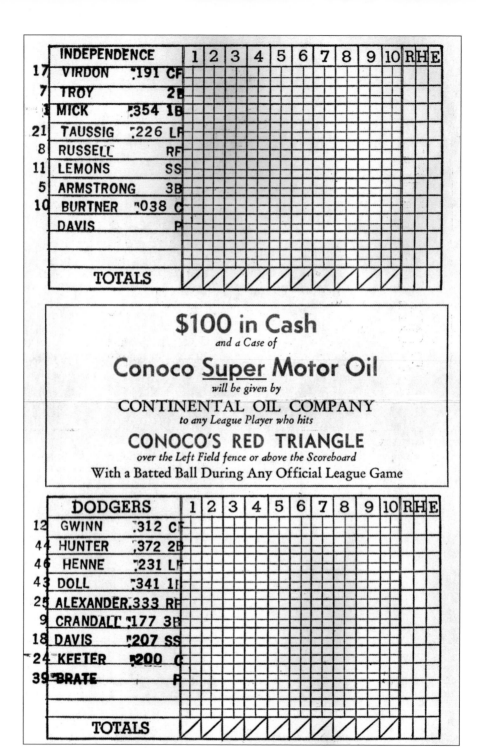

| INDEPENDENCE | | 1 | 2 | 3 | 4 | 5 | 6 | 7 | 8 | 9 | 10 | R | H | E |
|---|---|---|---|---|---|---|---|---|---|---|---|---|---|---|
| 17 | VIRDON .191 CF | | | | | | | | | | | | | |
| 7 | TROY 2B | | | | | | | | | | | | | |
| 3 | MICK .354 1B | | | | | | | | | | | | | |
| 21 | TAUSSIG .226 LF | | | | | | | | | | | | | |
| 8 | RUSSELL RF | | | | | | | | | | | | | |
| 11 | LEMONS SS | | | | | | | | | | | | | |
| 5 | ARMSTRONG 3B | | | | | | | | | | | | | |
| 10 | BURTNER .038 C | | | | | | | | | | | | | |
| | DAVIS P | | | | | | | | | | | | | |
| | **TOTALS** | | | | | | | | | | | | | |

| DODGERS | | 1 | 2 | 3 | 4 | 5 | 6 | 7 | 8 | 9 | 10 | R | H | E |
|---|---|---|---|---|---|---|---|---|---|---|---|---|---|---|
| 12 | GWINN .312 C | | | | | | | | | | | | | |
| 44 | HUNTER .372 2B | | | | | | | | | | | | | |
| 46 | HENNE .231 LF | | | | | | | | | | | | | |
| 43 | DOLL .341 1B | | | | | | | | | | | | | |
| 25 | ALEXANDER .333 RF | | | | | | | | | | | | | |
| 9 | CRANDALL .177 3B | | | | | | | | | | | | | |
| 18 | DAVIS .207 SS | | | | | | | | | | | | | |
| 24 | KEETER .200 C | | | | | | | | | | | | | |
| 39 | BRATE P | | | | | | | | | | | | | |
| | **TOTALS** | | | | | | | | | | | | | |

The comparison of the 1950 Independence and Ponca City batting averages would seem to indicate more of the Ponca City boys would have had careers in the major leagues. However, none of them made it while two of the Independence Yankees, batting .191 and .226, respectively, made it all the way to the top. (Courtesy of Bob Dellinger.)

William W. Sharp of Kansas City, Missouri passed away at the time the work on this book commenced. He played second base for the 1950 Iola Indians and then spent the next two years taking orders from Uncle Sam. After his stint in the Army, Willie returned to minor league baseball with Monroe, Louisiana in the Cotton States League. He was shuffled around in 1954, playing at Augusta, Georgia along with Tallahassee, Florida and Temple, Texas. After a full season at Hot Springs, Arkansas in 1955, he concluded his minor league playing career at Oklahoma City and Topeka in 1956. Willie played a lot of semi-pro ball after his professional career ended. He even returned to baseball to manage in the Northern League in the early 1990s. Sharp loved the game and shadows of his former ability were always evident, at KOM League reunions, when he took the field as a 70 year old and for a few moments imagined he was 17 once again. (Courtesy of Willie Sharp.)

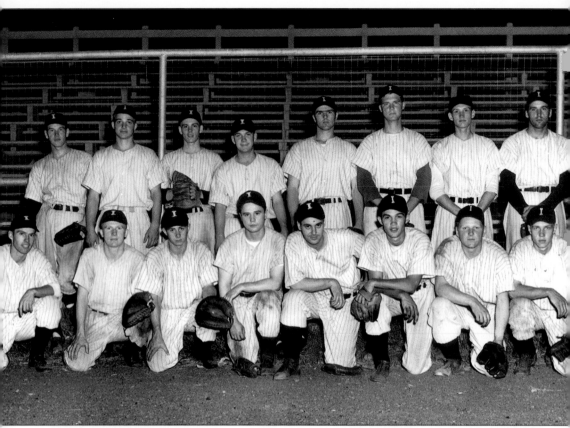

This is an early season photo of the 1950 Independence Yankees in what turned out to be the last season the New York Yankees sponsored a team in the KOM League. In the front row, from left to right, are Bunny Mick, Ray Burtner, unidentified, Mike Armstrong, Lou Michels, Glen Evans, Lloyd Price, and Bill Virdon. Behind them are Ken Beardslee, Don Taussig, Buddy Lemons, unidentified, unidentified, Wes Curtis, John Gabler, and Herbert Hoover Davis. Even though this was a sixth place ball club it produced three major leaguers—Bill Virdon, John Gabler and Don Taussig. (Courtesy of Lou Michels.)

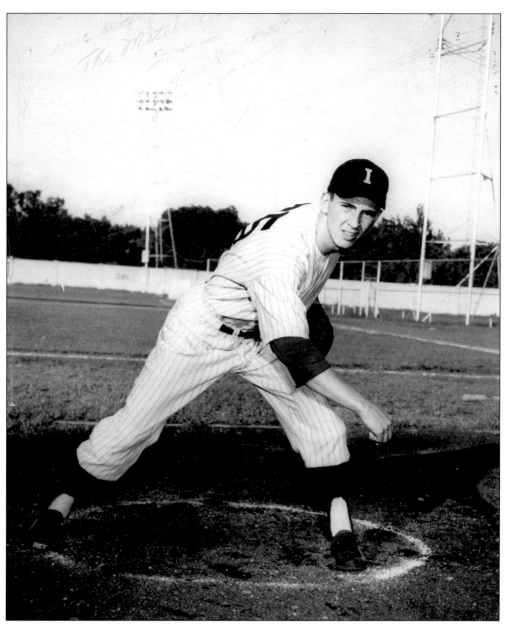

All former St. Louis native, Herb Heiserer, needed to look like a New York Yankee was a different baseball cap. The Independence Yankees always wore the hand-me-down uniforms of the New York Yankees. Most of the time the uniforms stopped in Kansas City for a year or two for that Yankee farm club, the Blues, to wear. Heiserer had four seasons in minor league baseball and made it as far as Beaumont in the Texas League before calling it quits. Many good players of that era went into the semi-pro ranks where they played fewer games and made more money than they did playing "bush league" baseball. Players falling into that category knew after a half-dozen years or so if they had a chance of making it up the ladder in the organization for whom they played. When they found out their ticket wasn't to the big leagues, they opted to play simply for the love of the game on some town or industrial league team. (Courtesy of Jeanne Mitchell-Grisolano.)

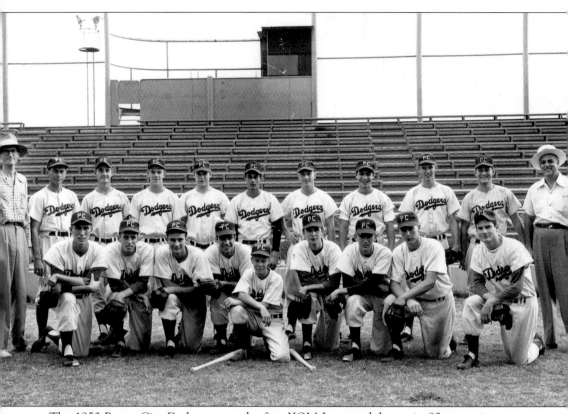

The 1950 Ponca City Dodgers were the first KOM League club to win 80 games in a season. That record was broken the next year when that club won 85 contests. That record was never eclipsed. The members of 1950 record-holding club, pictured here from left to right with position(s) listed, included (front row) Ernie Nichols (P), Bob Henne (OF), Mike Witwicki (OF), Ernie Jordan (P), Win Brown (batboy), Joe Stanek (P), Mike Werbach (P), Loren Doll (1B), and Connie Swensson (P); (back row) Jack Lewis (business manager), Boyd Bartley, (manager), Willie Davis (3B), Don Brate (P), Don Hunter (2B), Chuck Lamberti (P), Stan Gwinn (LF), Bob Bonebrake (CF), Harry Crandall (CF/3B), Don Keeter (C), and Ted Parkinson (club president). Most KOM teams couldn't control the positions of the players since the parent clubs moved them around like checkers. However, the Brooklyn organization was grooming players for specific tasks and wanted their minor league managers to play them on a regular basis at those positions. (Courtesy of Don Keeter.)

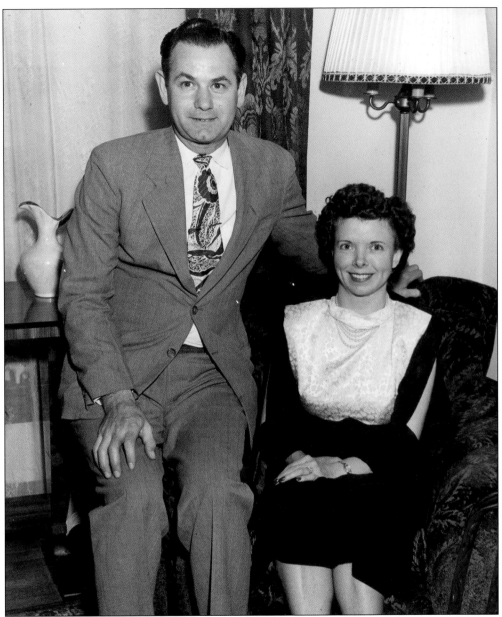

Charlie and Dixie Bates were photographed in 1947 at their home in Chanute, Kansas. They were neighbors of the Lightfoot family, who preserved this photo. Bates managed the Chanute Athletics in 1947 and parts of 1949 and '50 seasons. By the time he showed up in the KOM League he had played professional baseball since 1924, with the exception of the 1936 and '37 seasons. In 1928 he had a brief stint with the Philadelphia Athletics. He played in just about every classification of baseball, including semi-pro baseball with the Wichita Beachcraft Flyers in 1942 and 1943, and then with the Topeka, Kansas Decker Oilers in 1948. (The father of Harland and Burton Coffman, both of whom played in the KOM League, managed the Decker Oilers. They also performed with the Oilers before and after their professional careers.) At the age of 45, Bates gave up playing baseball and returned to his adopted hometown of Topeka, Kansas. He passed away there on January 19, 1980. (Courtesy of Barbara Lightfoot-Allison.)

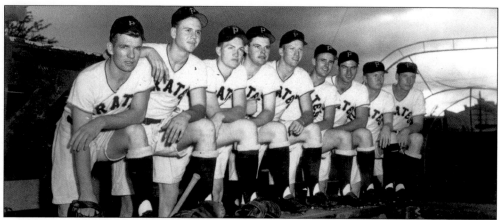

The Pittsburgh Pirates had an experiment that was initiated in the Pacific Coast League and was to be conducted throughout their minor league system. The novelty was to put their players in short pants. By late July the pants had reached the KOM League. On July 20, 1950, the following fellows appeared in the *Bartlesville Examiner*: David Elliott, Bobby Graham, Harold White, Charles Sauvain, Ed Wolfe, E.C. Leslie, Don Hinchberger, Leroy Mehan and Jim Ryan. Manager Tedd Gullic went along with the "stunt" for one week and called a halt to it. He claimed it affected the performance of his team since no one would slide for fear developing "raspberries." (Courtesy of Don Hinchberger.)

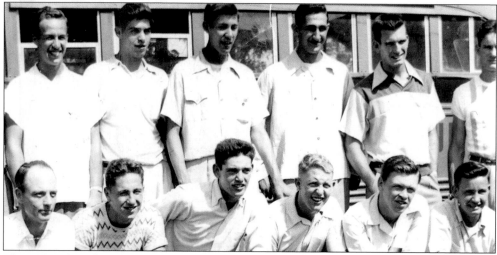

The 1950 Iola Indians had a lot of problems, not the least of which was getting the whole team together for a photo. There appears to be a couple of other guys "in the area" but they could not decide whether to board the bus or smile for the photographer. This team avoided winding up in last place by virtue of winning 35 games and losing 84. Chanute nosed them out for the basement by playing five more games and losing every one of them. There is something to be said for not making up rainouts. The Iola players squeezing into this photo, from left to right, are (front row) Windy Johnson (manager), Howie Hunt, Willie Sharp, Ed Simmons, Leo Kedzierski, and Emil Jurcic; (back row) Bill Hahn, Fred Wehking, Gordon Budd Maxwell, Ray Khoury, Bennie Leonard, and Ed Scott. Howie Hunt, a pitcher for this club, maintains that of the 35 wins he and Emil Jurcic accounted for 25 between them. He claims they both won 12.5 games. That is what happens to guys with last place (or near-last place) teams, they just have a difficult time with reality. (Courtesy of Willie Sharp.)

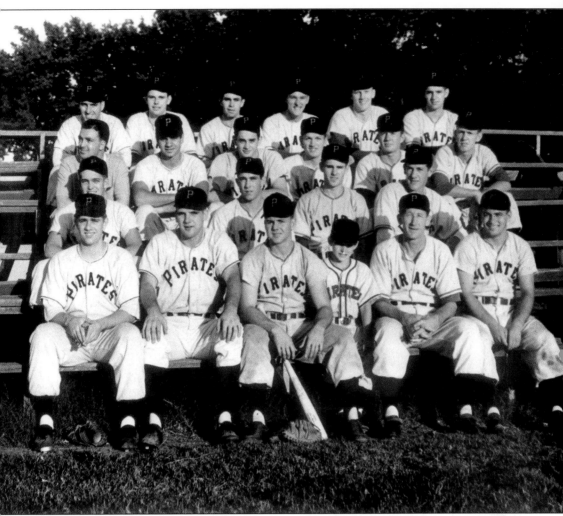

Tedd Gullic managed the Bartlesville Pirates from 1949 to 1951 and had the best record of any manager in the KOM. However, he never won a pennant or playoff series with the talent available. Either the Ponca City Dodgers, Independence Yankees or the Pittsburgh Pirates front office were always his roadblock to winning a championship. In 1951 his top two performers, Ronnie Kline and Brandy Davis, were shipped out to the New Orleans Pelicans during the stretch drive of August. Pictured from left to right are (first row) Ronnie Kline, Jerry Dahms, Bobby Joe Graham, Phil Thompson-Batboy, Tedd Gullic, and Harry Neighbors; (second row) Jim Williams, Harold Blaylock, E.C. Leslie, and Bob Bonaparte; (third row) Don Labbruzzo (business manager), Sal Campagna, Segal "Cotton" Drummond, Hal White, Leroy Mehan, and Don Cochran; (fourth row) Don Hinchberger, Chuck Sauvain, Dean Miller, John Gilbert, Ed Wolfe, and Tom Gera. (Courtesy of Don Hinchberger.)

Paul Hoffmeister had two shots at the KOM League. He started the 1949 season at Carthage and after being sent to Mattoon, Illinois for the remainder of that season he came back to Carthage in 1950 to pose in his "new" hand-me-down Chicago Cub uniform. After a two-year absence from the game, Hoffmeister returned in 1953 with Cedar Rapids, Iowa in the Three-I League. He played in the Texas, Western and Pacific Coast leagues, ending his career with Portland in 1958. (Courtesy of Paul Hoffmeister.)

One of the most popular landmarks around the KOM League was the Jasper County Courthouse at Carthage, Missouri. Many of the visiting team players would depart the Drake Hotel during the day to eat lunch on the town square and sit under the elm trees to "watch the world go around the square." This was a penny postcard that Carthage pitcher, Paul Hoffmeister, sent home to his parents in Chicago on May 4, 1950. The message read: "Dear Mom and Papa—Just a card this time. It's late and I want to send my new address. I haven't received a letter in a long time so I thought maybe its because you haven't my address. I'm starting tomorrow nite, the second game of the year. Here's hoping its No. 1, but Miami has a darn good club and us no hitters. Love Paulie. 200 N. McGregor. Carthage, Missouri."

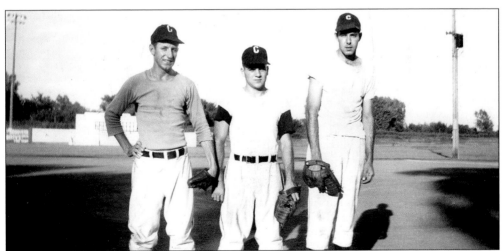

The collection of photos from Bernie Tye the inscription reads, "Outfield Chanute 1950." Tye could recall the name of Tom Imfeld on the far right but the fellow in the member remains unidentified. However, Bernie (far right) was probably the most recognizable player in the history of the KOM League. He played from 1946 to 1950 with Chanute, Iola and concluded his career with Chanute. If ever a person loved a league it was Bernard Francis Tye. The KOM League loved him to. His final words uttered to this author on the day before slipping into a coma was, "I love you man, and everyone ever affiliated with the KOM League." (Courtesy of Bernie Tye.)

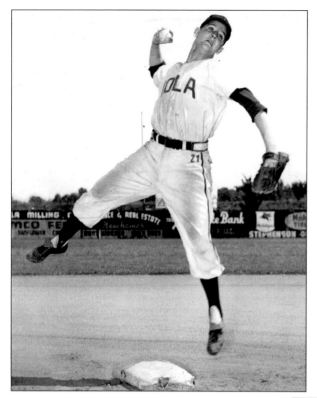

Bernard Leroy Coulter was a native of Eldon, Kansas who played most of his career in the KOM League. He spent two seasons at Chanute and one with the Iola Indians, his most productive. The 1952 season earned him a shot with Texarkana, Texas in the Big State League. Coulter later became one of the first Drug Enforcement Agents in the United States. He died at the young age of 57 in 1988. (Courtesy of Willie Sharp.)

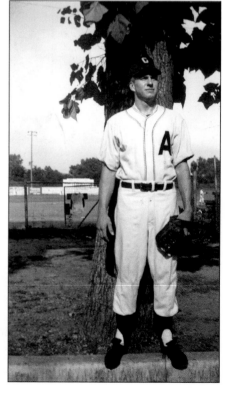

Peter Swain of the 1950 Chanute Athletics just looks like the prototype of a hard throwing right-handed pitcher. He joined the Chanute club in early July. He had spent the previous year with Marysville, California in the Far West League. The Laurel, Nebraska native had started his career at Newark in the Ohio State League in 1947. In many years of research, Mr. Swain was never located although the best information available indicates he was probably living in California. (Courtesy of Dave Newkirk.)

Jack Brown, shortstop for the 1950 Pittsburg Browns was photographed on June 30, 1950. He commented, "On this date Browns equal 1949 record of 39 wins of for entire season." Brown attended The College of the Pacific and was the back-up quarterback to Eddie LaBaron who later played for the fledgling Dallas Cowboys when they entered the National Football League. (Courtesy of Jeanne Mitchell-Grisolano.)

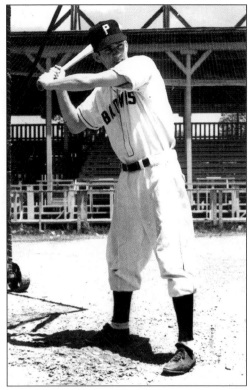

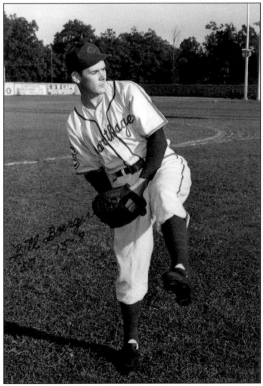

Willard Boerger started his baseball career at the age of 16 in 1945 with Marion of the Ohio State League. Many young boys, due to the shortage of players precipitated by the war, played professional baseball during the summer while still in high school. A number of fellows, like Boerger, played in 1945, and then after the veterans returned home to fill those roster slots, the young "stars" of 1945 didn't reappear on the scene until 1948. Boerger was 21 years old by the time he arrived at Carthage in 1950, where he posted a 15-8 record. That earned him a promotion, in 1951, to the Topeka Owls of the Western Association. Boerger graduated from college and spent the next three decades coaching high school sports in his native Ohio and later California where he became a big winner and "legendary" figure. (Courtesy of Willard Boerger.)

Robert Halsey Bonebrake could play baseball and the piano, and both on the ball diamond as depicted during talent night at Ponca City, Oklahoma in 1950. Bonebrake spent two seasons with the Ponca City club and was best remembered for his foot speed. The native of Portland, Oregon had started his career in 1948 and then worked his way through many of the Dodger minor league clubs by the end of the 1952. Aside from Ponca City he spent time at Medford, Oregon; Billings, Montana; Greenville, Mississippi; Newport News, Virginia; Lancaster, Pennsylvania and Hornell, New York. He concluded his career with Calgary in 1953. (Courtesy of Bob Dellinger.)

Edward Donald Hinchberger was one of the finest gentlemen this author ever met. He once stated that the greatest disappointment in his life was being sent from the Class C Hutchinson Elks back to the Class D Bartlesville Pirates. He had that sense of loss from 1950 until 1996 when he learned of the effort to revive the memory of the KOM League. He said that being able to associate with members of the league again through reunions and the KOM League newsletter that he was happy he hadn't made it in Class C baseball. During his time in hospice shortly before his passing, in 1999, he called to say he was designating the KOM League newsletter as the beneficiary of his memorial gifts. His wish was honored by his friends and loved ones and a half-decade after his death those gifts are still helping keep the KOM League newsletter alive. Hinchberger left professional baseball after the 1952 season and played semi-pro baseball during the summers afterward. He received a degree in education and taught at the same high school in Torrance, California his entire career. Hinchberger is captured in this photo wearing his Hutchinson Elks home uniform. (Courtesy of Don Hinchberger.)

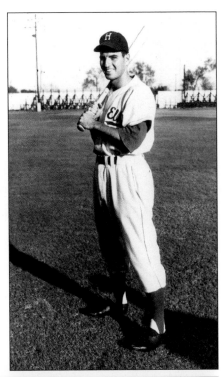

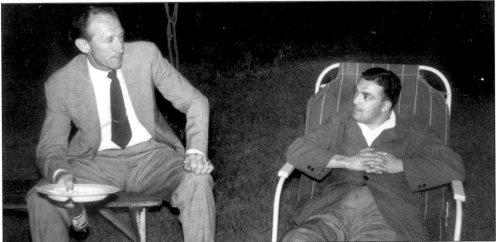

Tedd Gullic, manager of the 1950 Bartlesville Pirates and Don Labbruzzo, business manager, take time out to enjoy a party at the ranch of Bartlesville booster, Jack Bockius. Gullic was born at Koshkonong, Missouri in 1907. He started his pro career at Muskogee, Oklahoma in 1928. He didn't play in 1929 due to and injury but joined Milwaukee in the American Association in 1930. He spent time with the St. Louis Browns in 1930 and 1933 and never got another chance at playing in the major leagues. He was with Milwaukee from 1934 to 1938 and then spent four years in the Pacific Coast League. After a stint in the Western International League, Tedd returned to the Midwest to manage Bartlesville for three seasons. After the KOM League folded, he managed at Waco in the Big State and Magic Valley in the Pioneer leagues. When this author asked Gullic why he "rode the busses" all those years his reply was simply, "I loved the game." Gullic lived to be 95. (Courtesy of Tedd Gullic.)

Phil Costa experienced a different world in Carthage, Missouri and the towns of the KOM League than what he had grown accustomed in Chicago. He had never heard of chicken fried steak and was amazed that no one in Carthage served pizzas. In fact none of the locals had ever heard of it. Having been raised around the lore of the Chicago gangsters, Costa was intrigued by the outlaws of the area that comprised the KOM League. As the Carthage bus passed through Coffeyville, Kansas, Costa urged manager Don Anderson to let him out and he would rejoin the team in Independence later that day. When pressed as to why he wanted to stay in Coffeyville he responded with, "I'll finish what the Dalton Gang started." That was in jest regarding the townspeople of Coffeyville taking matters into their own hands when the "gang" attempted what became their last bank heist attempt. (Courtesy of Phil Costa.)

Mike Witwicki, a native of Toronto, Canada rode the busses through the Brooklyn Dodger farm system at Ponca City, Oklahoma for two years, and also with Greenwood, Mississippi; Newport News, Virginia; Great Falls, Montana; Cedar Rapids, Iowa; Bakersfield, California and Pueblo, Colorado. On a trip with Pueblo in 1954 one of his teammates complained that he didn't belong in the minor leagues but rather should be starring in the big leagues. Witwicki told the young shortstop that they were both destined never to rise above the minor league level. The right-handed hitting shortstop persuaded the Dodgers to let him learn to switch hit. Witwicki surmised that had the Dodgers allowed him to switch-hit there could have been two guys at Ebbets Field with the initials of "MW," instead of just the one, Maury Wills. (Courtesy of Mike Witwicki.)

Harry A. Crandall was an outfielder for the 1950 Ponca City Dodgers after being sent down by Pueblo, Colorado of the Western League. The Los Angeles native played for Boyd Bartley's pennant winning and playoff championship club that season and never played afterward. However, he has had a streak of consecutive KOM League reunions, unbroken except for one year when there was illness in the family. Crandall was in the airline industry all of his working life and now resides in Denver, Colorado. It is a great "jumping off" point to attend KOM League functions no matter the location. (Courtesy of Harry Crandall.)

James W. Waugh saw action at Pittsburg, Kansas in both 1949 and 1950. He was a native of Huntington, West Virginia. The St. Louis Browns had hopes for him as they moved him through their system prior to his entry into the Korean War. After he returned from the service the Browns were the Baltimore Orioles and he was left to fend for himself without affiliation with any major league team. He concluded his career in 1956 with Pampa, Texas of the Southwestern League. In this photo he shared with the Mitchell family, he is wearing the uniform of the Aberdeen Pheasants that was a lot more attractive than the one worn by the Pittsburg Browns. (Courtesy of Jeanne Mitchell-Grisolano.)

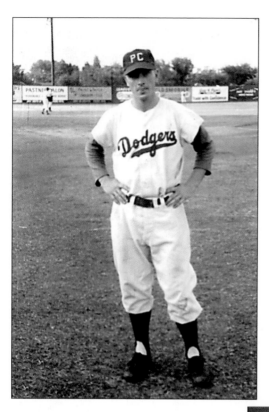

Stanley Harrison Gwinn of Yale, Oklahoma was signed by the Brooklyn Dodges upon graduation from Oklahoma A & M (now Oklahoma State University) in June of 1949. He was sent to Ponca City where he hit .281 in his first KOM season. Gwinn was known for power, speed and hitting for average. In 1950 he hit 10 home runs, stole 57 bases and beat out Bunny Mick of Independence for the batting title, .3199 to .3198. Ten home runs doesn't sound like a large number but some KOM League teams would go an entire year and only hit that many. (Courtesy of Bob Dellinger.)

Bill Virdon rated Jim Pisoni, shown here, as the best player he went up against in the 1950 KOM League season. The St. Louis native had started with Mayfield, Kentucky in his first year in the St. Louis Browns organization. After a couple of years in the service Pisoni made his appearance in his hometown with the Browns in late 1953. He played win the Texas League in 1954 and 1955 before going to the Pacific Coast League in 1956. He got another shot with Kansas City in late 1956 and then didn't see the major leagues again until 1959. He also spent time with the Milwaukee Braves that same year and then saw additional action with the Yankees in 1960 his final season in baseball. Pisoni loved the folks in Pittsburg, Kansas especially the Mitchell family. Their photo collection contained more photos of him than any other player in Pittsburg history. (Courtesy of Jeanne Mitchell-Grisolano.)

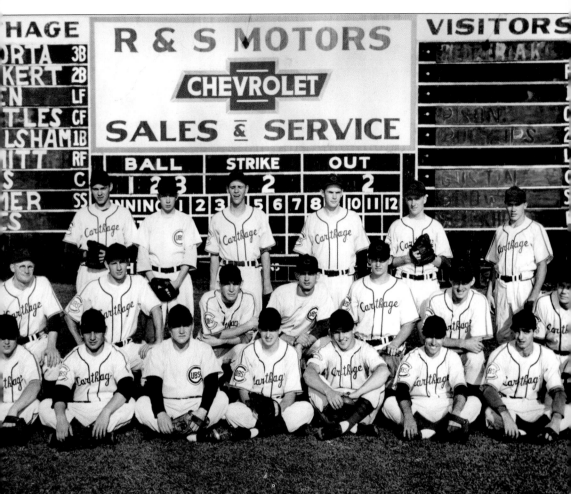

If a scoreboard is in the background the Carthage Cubs must be in the foreground. In this is 1950 version of the Chicago Class D affiliate, pictured from left to right, are (front row) Duane Zimmer, Art Gapinski, Dale Loeber, Ralph Brockert, Don Biebel, Johnny LaPorta, and Woody Weuthrich; (middle row) Don Anderson, Sam Wattles, Dean Manns, Benny Bennett, Don Annen, and Tom Vines; (back row) Leonard Vandehey, Jack Milster, Jerry Rendelsham, Bill Boerger, Bud McClure, and Don Schmitt. None in this group made it to the major leagues as a player, but Don Biebel served as the traveling secretary for the Chicago Cubs during the 1960s before becoming the Director of Public Relations the last year Kansas City was known as the Athletics. (Courtesy of Woody Weuthrich.)

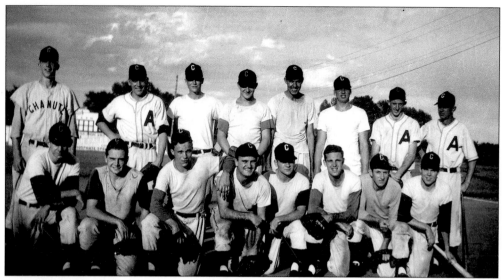

This is the last team photo taken of the Chanute Athletics. After the last game of the 1950 season all the members of that club stood along the third base line and sang, "Goodnight Irene." This "rag-tag" photo, from left to right, includes (front row) Ray Hrabos, unidentified, Pete New, Mace Pool, Bob Genette, Sam Dixon, Tom Imfeld, and Tom Norbut; (back row) Dave Newkirk, Howard Burchett, Manley "Bud" Fossen, Morris "Morie" Shipman, Bernie Tye, Mickey Willett, and Chuck Hostetler. (Courtesy of Sam Dixon.)

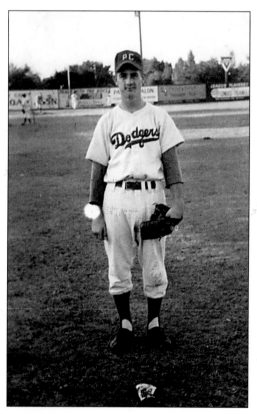

Willard Davis of the Ponca City Dodgers was known as a slugger. He led the league in homers with 21, and in 122 games struck out 169 times. That was the largest number of strikeouts by any batsman in league history. He also led the league in errors for third basemen. However, his strong bat carried him as far as Pueblo in the Western League in both 1954 and 1955. That was Davis' last season in professional baseball but he continued to have a lot of success in the semi-pro ranks. He led Perry, Oklahoma to the state semi-pro championship in 1957. (Courtesy of Bob Dellinger.)

Loren Doll spent two seasons on the Brooklyn Dodger farm with Ponca City. The opposing players had high regard for the good hitting and fine fielding first baseman. The Dodge City native played three seasons in the Dodger system. He ended his career in 1953 at Hutchinson, Kansas in the Western Association and was still one of the best fielding first basemen in the league, and after a year layoff in 1952 still hit .270. After giving up baseball Doll got into the beef business and had one of the largest cattle feeding operations in the State of Kansas and probably the United States. (Courtesy of Loren Doll.)

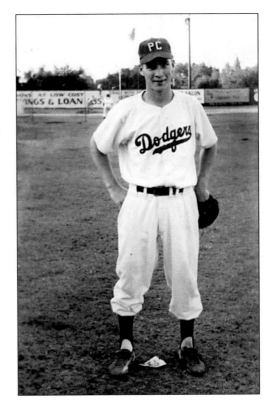

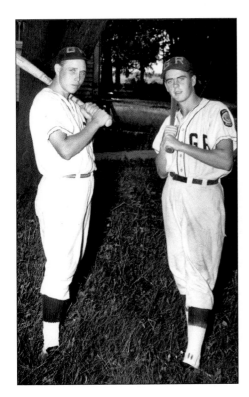

Eldon Yung (right) and Kendall Moranville joined the 1950 Miami Eagles out of the small Southeast Nebraska town of Guide Rock in May of 1950. Some media hype occurred upon Moranville's signing. KGLC radio announcer, Russ Martin, claimed he was kin to Rabbit Maranville. It didn't matter that the announcer was also a local minister and the names weren't spelled the same. Moranville's career ended within a week and Yung stayed around for a couple of weeks. Both were good enough to have lasted the season but owner Francis A. "Pug" Griffin was doing all he could to make money. Shortly after disposing of Yung and Moranville, he absconded with the money raised from pre-season box seat sales. The KOM League hierarchy trailed him to Colorado Springs, Colorado but never pressed any charges, for Griffin died in October. Yung went on to get his PhD and taught at Central Missouri State University until his retirement. Kendall Moranville had a long career in the Navy, and on the same day Mickey Mantle retired from baseball Admiral Moranville took over the command of the United States Naval Fleet in the Mediterranean. (Courtesy of Dr. Eldon Yung.)

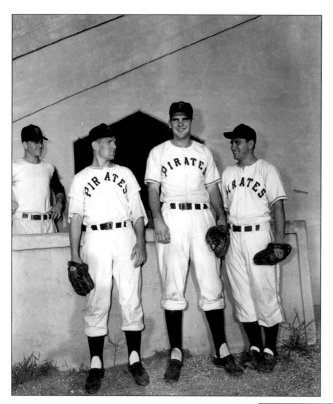

At the mid-point of the KOM League season, the team in first place would host the all-star game and the best players from the remaining teams would form the opposition. In 1950 the Pittsburg Browns held down first place and had the opportunity to take on "all-comers." They shut out the All-Stars 6-0. The top players sent by the Bartlesville Pirates to that game were left-handed pitcher David Elliott (left), catcher Jerry Dahms (center) and outfielder Harry Neighbors (right). Bobby Joe Graham is in the background wishing he was making that trip or maybe just giving thanks for having a day off. (Courtesy of Bobby Joe Graham.)

Joe Stanek of Omaha first appeared in the KOM League in 1949 and returned in 1950. He progressed rapidly through the Brooklyn Dodger organization after proving he had pitching talent. He played for Elmira in the Eastern League in 1951 and then served in the United States Coast Guard for two years. In 1954 he was pitching in the Western and Texas leagues. Stanek made it to Montreal of the International League in 1955 and spent time between the St. Paul Saints and Montreal Royals, top Dodger farm clubs in 1956. He stayed with the game until the 1958 season where he quit after a season with Des Moines in the Western League. His love for baseball didn't end. He got into umpiring college games and was a fixture as the "man in blue" for Big Eight Conference baseball (now the Big 12) and umpired many years at the College World Series in Omaha. He still resides in Nebraska's largest city. (Courtesy of Bob Dellinger.)

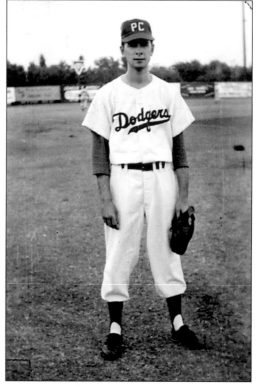

# SIX

# The 1951 Season

## *The League*

## *Suffers Attrition*

Should any reader wish to place blame on any team, or any year, for this book ever coming about, they can "lay it on" the 1951 KOM League season in general, and the '51 Carthage Cubs in particular. That was the summer this author got to be the home team batboy.It never made the headlines nationally or even got mentioned in the local *Carthage Evening Press*.

The newsworthy events of the day were such items as: "The Death of Charles Nessler." He died on January 22 and his lasting memorial was that he invented the permanent wave. (The one done on ladies hair, not the one done in stadiums). Moviegoers were watching Humphrey Bogart in "The Enforcer." The United States Congress was doing a little enforcing on their own by limiting the term of Presidents to two terms. (Since that time some folks have figured out that one term is enough for most Chief Executives and two too many for others.)

Julius and Ethel Rosenberg were found guilty of selling atomic secrets to the Russians on the last day of March. It was an emotional trial at the time America was knee deep in the Korean snows. Gen. Douglas McArthur was warning that the war might spread to China. He uttered those words the same day Ethel and Julius were found guilty and Harry Truman didn't think the General's words should go unpunished either. Thus, eleven days later, Truman fired McArthur and the uproar was heard around America.

It didn't bother Harry that much and six days later his daughter, Margaret, made her first radio appearance on the program, "Jackpot".

There was entertainment in the small Midwest towns if "A Streetcar Named Desire" made it to the local theater. Yul Brenner played his first performance of "The King and I," in March, but that show never played on the stage of any theater in a KOM League town.

Simultaneous with the start of the baseball season, RCA broadcast television in color for the first time, from the Empire State Building, on May 2. Those color signals didn't reach our part of the Midwest for the next decade, plus. Americans may not have had access to color TV but they were affluent. The average family income nationally was $1,436 and a Class D ballplayer could earn up to $600 per season if he stayed the entire four months.

Four months after Truman fired McArthur, 90 West Point Cadets were expelled for cheating. McArthur got his ticker tape parade as the "Vanquished General" and prejudice reigned for a fallen warrior from the Korean War. John Rice of Winnebago, Nebraska was denied burial by the Mayor of Sioux City, Iowa because of his Indian heritage. Mr. Rice was interred at Arlington National Cemetery instead.

Sports made the news on many fronts. Sugar Ray Robinson beat Jake LaMotta on February 14, and maintained the crown until July 10. That was a memorable evening. A certain unnamed Carthage Cub pitcher by the name of Walter Babcock had heard the results of the fight between Robinson and Englishman, Randy Turpin. This author also knew Robinson won.

However, Babcock placed a number of sure bets that night before the game and cleaned out some unsuspecting teammates. On September 12, Robinson turned the tables on Turpin but Babcock couldn't find any "suckers" that night.

Joe Louis came out of retirement on October 27 against Rocky Marciano and went right back into it after the fight.

America got around to signing a truce creating a neutral zone at the 38th Parallel that exists until this day. But it did not stop the hostilities and two former KOM Leaguers—Walt Kohler of Carthage and John Lazar of Pittsburg—were casualties of that undeclared war.

Bobby Thomson authored "The shot heard around the world" to win the playoffs for the Giants over the Dodgers, but the Yankees prevailed in the World Series.

Unbeknownst to this author, his affiliation with minor league baseball would end with the close of the 1951 season. Carthage never fielded another team. The old ballpark never saw another pro team and the only games played there now are in our memory.

## SUMMARY OF KOM LEAGUE DATA FOR 1951

| Team Standings | Won | Lost | Pct. | GB |
|---|---|---|---|---|
| Ponca City Dodgers | 85 | 39 | .686 | — |
| Bartlesville Pirates | 77 | 45 | .631 | 7 |
| Miami Eagles | *67 | 55 | .549 | 17 |
| Carthage Cubs | 60 | 65 | .480 | 25.5 |
| Pittsburg Browns | *41 | 80 | .339 | 42.5 |
| Iola Indians | 38 | 84 | .311 | 46 |

*Indicates tie
Carthage defeated Miami, 3 games to 0 to win the playoffs.

## LEAGUE LEADERS

### BATTING
Average: .365, Jack Denison, Ponca City Dodgers (He beat out James Eldridge, Miami Eagles by .006.)
Home runs: 13, Robert "Brandy" Davis, Bartlesville Pirates.
RBI: 89, Robert Ottesen, Pittsburg Browns
Stolen bases: 71, Morris Mack, Ponca City Dodgers (Brandy Davis had 68 with a month left in the season when he was called up to the New Orleans Pelicans.)

### PITCHING
ERA: 2.12, John Mudd, Carthage Cubs
Wins: 18-4, Ron Kline Bartlesville; 18-6, Donnie Cochran Bartlesville (Kline was summoned to New Orleans with a month left in the season.)
Strikeouts: 208, Ron Kline
Shutouts: 4, Ron Kline and Tommy Warren, Miami Eagles.

### ATTENDANCE
Bartlesville: 34,296
Carthage: 20,022
Iola: 16,984
Miami: 23,500
Pittsburg: 22,534
Ponca City: 44,960

PLAYERS FROM 1951 KOM LEAGUE TEAMS WHO MADE IT TO THE MAJOR LEAGUES
Bartlesville: Robert "Brandy" Davis and Ronald Lee Kline
Ponca City: Joe Stanka (also became the first American hero of Japanese baseball with the Nankai Hawks).

MANAGERS IN THE KOM LEAGUE IN 1951 WITH PREVIOUS MAJOR LEAGUE EXPERIENCE
Bartlesville: Tedd Gullic
Miami: Francis "Pug" Griffin and Tommy Warren
Ponca City: While he didn't have Major League experience, George Scherger, the Ponca City manager, later became the first base coach for Sparky Anderson during the "Big Red Machine" days of the Cincinnati Reds in the 1970s.

Albert C. Solenberger of Springfield, Ohio holds the record for the most hits in KOM League history, at 401. He spent three seasons in the league in 1947, 1948 and 1951. He was the model for consistency. In those years he had 131, 134 and 136 hits and batted .300 in both 1948 and 1951 while hitting .321 in his final season, 1951. Solenberger spent the 1949 and '50 seasons at Davenport, Iowa and Modesto and Stockton in the California League. (Courtesy of Al Solenberger.)

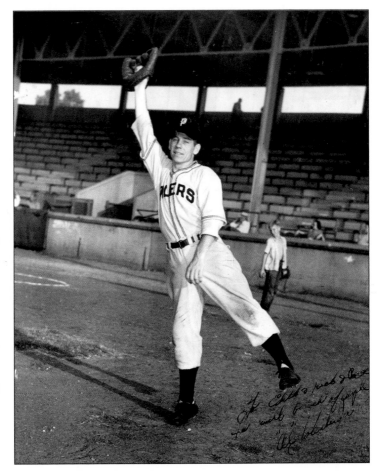

99

Ballplayers always enjoyed seeing their name in lights. The only lights on the Carthage scoreboard were for balls, strikes and outs. The rest of the items were hung on either end of the scoreboard, on hooks, by the groundskeeper who doubled as the scoreboard operator. All names were painted on large pieces of slate with whitewash. The image became clearer as the whitewash dried. Any faint name on the scoreboard indicated that person had just entered the game. When a player left the game the slate was washed and another name added, and sometimes both the name of the player who left the game and the one entering could be seen on the slate. This photo is from a 1951 game at Carthage between the home team and the Iola Indians. Stan Klemme wrote on the back of the photo, "I hit a ball over the scoreboard in batting practice. I was told the only other player to do this was Stan Musial." Musial had done it in a Western Association game against the Carthage Pirates in 1941. However, a number of fellows hit some shots that cleared the scoreboard after the KOM League came into existence in 1946. (Courtesy of Stan Klemme.)

The scoreboard depicts a game between the 1951 Carthage Cubs and the Bartlesville Pirates. The second place hitter that evening for Bartlesville was Brandy Davis. He along with teammate Ronnie Kline were two of the premier players in the league that year and were called up to New Orleans before the season ended. In their final KOM League game, Kline shutout Carthage and Davis homered. We know this game was played prior to July 9, due to the name of Don Anderson batting third and playing second base. He was released as manager on that date. (Courtesy of Brandy Davis.)

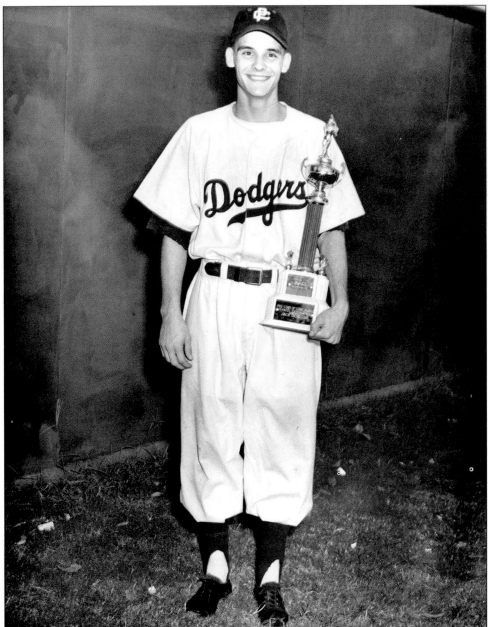

Jack Denison deserved a trophy after waging a terrific race for the 1951 batting title with Windy Eldridge of the Miami Eagles. He beat out Eldridge by .006, but his real fight was for the all-time KOM League. Denison came to bat in the ninth inning of the final game of the season needing a hit. A base on balls, a hit batsman or a fielding error would ensure that Loren Packard of the 1947 Miami Owls would be the "all time leader." Bob Dellinger was covering the game for the *Ponca City News* and recalled the excitement of Denison's last at-bat. When he put the ball into play it was a routine grounder to the shortstop that appeared to be a sure out. However, Denison reached deep inside for that extra burst he had displayed while running in many track meets. When the umpire gave the safe sign, Denison had become the all-time KOM League batting leader by ousting Packard by a margin of .00055. (Courtesy of Bob Dellinger.)

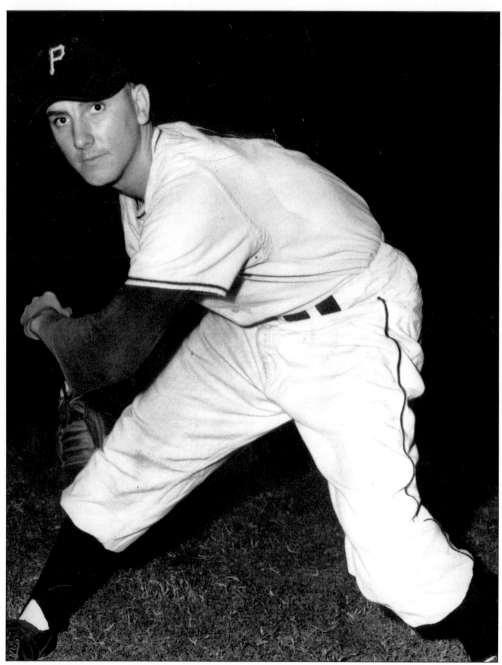

Don Gebbs was a rare item on the 1951 Bartlesville pitching staff. The New Orleans native was a left-hander. He posted a 6-2 record during his abbreviated time in the KOM League. However, his short stay provided many memories that he thought most everyone of his teammates had probably forgotten. When he was located in 2002 he was thrilled to learn the KOM League was being remembered through reunions and newsletters. Gebbs has attended every KOM League reunion since he was located and promises to attend them as long as they continue. (Courtesy of Don Gebbs.)

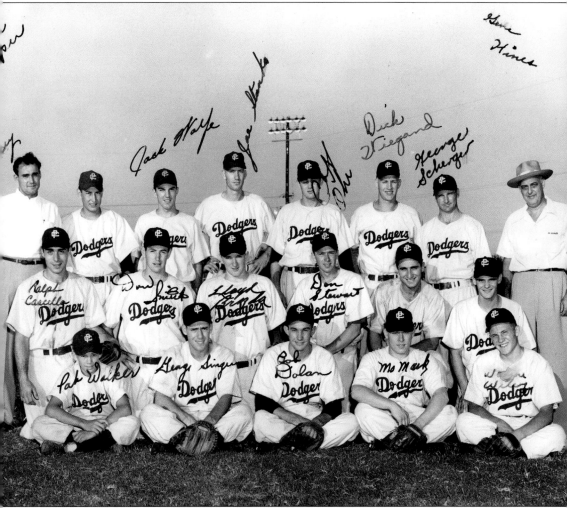

The 1951 Ponca City Dodgers had a different manager than in the preceding four years. Former manager, Boyd Bartley was called back into the service and was running the baseball operations at Ft. Chaffee, Arkansas. The Dodgers brought in playing manager, George Scherger. Scherger later made it to the major leagues as the first base coach for the "Big Red Machine" during Cincinnati's National League dominance of the 1970s. His Ponca City club, seen here from left to right with position(s) listed, included (front row) Pat Walker (batboy), George Singer (P), Bob Dolan (SS), Morris Mack (3B), and Wayne Wiley (2B/SS); (middle row) Ralph Cascella (P), Don Smith (P), Lloyd Brazda (P), Don Stewart (OF), Stan Santo (1B), and Jack Denison (OF); (back row) Paul Vickery (business manager), Eldon DeRoin (P), Jack Wolfe (C), Joe Stanka (P), Cliff Ohr (P), Dedrich Wiegand (P), George Scherger (manager), and Ted Parkinson (president). Joe Stanka played for the Chicago White Sox before heading to Japan to become the first American to be a true hero of the Japanese major leagues. In 1964 he won three games to lead the Nankai Hawks to the championship. (Courtesy of Jack Denison.)

**CHICAGO CUBS** 🐻 **MINOR LEAGUE SYSTEM**

TELEPHONES BUckingham 1-5050 OR EAstgate 7-5155 • HOME OFFICE WRIGLEY FIELD, CHICAGO 13, ILLINOIS

JOHN T. SHEEHAN, President •JAMES T. GALLAGHER, Vice President •HAROLD K. GEORGE, Vice President •MARGARET DONAHUE, Secretary • EARL W. NELSON, Treasurer

January 19, 1951

Mr. Lee Newman, Pres.
Carthage Baseball Club
Carthage, Mo.

Dear Lee:

Enclosed is letter from Player Hugh Wolf and copy of my reply to same, both of which are self-explanatory.

Please handle as you see fit.

John Mann, of the Janesville Club, was in yesterday and informed me that their club will again train in Carthage. He also said that Topeka had definitely decided to train there. I should like to suggest that Reuel King give some thought to checking with all clubs, Janesville, Sioux Falls and Topeka, to arrange a schedule of exhibition games, as these clubs desire,that will not conflict in any way with the use of your diamonds there. Also some thought should be given to the hours that each club will train and the particular diamond that they will use as well as the possibility of trading off weekly so that each club gets a shot at the better diamond.

With best regards.

Sincerely,

*Jack Sheehan*

Director of Minor League Clubs

JTS/j

encls.

---

At the start of 1951 "everyone" wanted to come to Carthage. This letter indicated that the Topeka Owls, Janesville Cubs, and the Sioux Falls Canaries would join the Carthage Cubs for spring training. That meant a lot to this author for there were three venues where a kid could go on Saturdays and Sundays and pick up a few broken bats and find a way to come up with enough baseballs to last most of the summer. It is hard to describe the joy of seeing the team busses rolling around Carthage early in the Spring and knowing that baseball was returning. Having nearly 200 fellows in town attempting to make their respective ball clubs was a great time for a pre-teenage kid who loved everything about baseball, even the games that were often played during snowstorms. (Courtesy of the Reuel King family.)

# TOPEKA BASEBALL CLUB, Inc.

L. D. NORRIS, PRESIDENT
LESTER M. GOODELL, VICE PRES.
JOE GARRISON, SEC.-TREAS.
E. L. "BUTCH" NIEMAN, MGR.

OWLS

ORPHEUM BUILDING — TOPEKA, KANSAS

January 12, 1951

Mr. L. E. Mewman, Pres.
Carthage Baseball Assc., Inc.
Carthage, Missouri

Dear Mr. Newman:

    With reference to your letter of January 5, relative to the Topeka Club training in Carthage.

    Mr. Norris, our President, and myself would like to make an appointment with you for January 22. We will leave here early that morning and would like for you to have lunch with us. That will give us the afternoon to look around and make the necessary arrangements.

    Trusting this will meet with your approval, and would appreciate your advising as to where we can meet you. With kindest regards, we are,

Most sincerely,
TOPEKA BASEBALL CLUB, INC.

*"Butch" Nieman*

ELN/r

E. L. "Butch" Nieman
Manager

Former Boston Brave, Elmer "Butch" Nieman was slated to manage the Topeka Owls in 1951 and he was anxious to meet with the Carthage officials regarding getting set up for the spring. By the end of 1951 things weren't as rosy for the Carthage baseball fans, and by 1952 the city was no longer a member of any professional league. Fortunately, for this author's bat and baseball supply, the Janesville, Sioux Falls and Topeka teams showed up in the spring of 1952 to prepare for their upcoming season. That was the last year any professional team ever trained in Carthage. (Courtesy of the Reuel King family.)

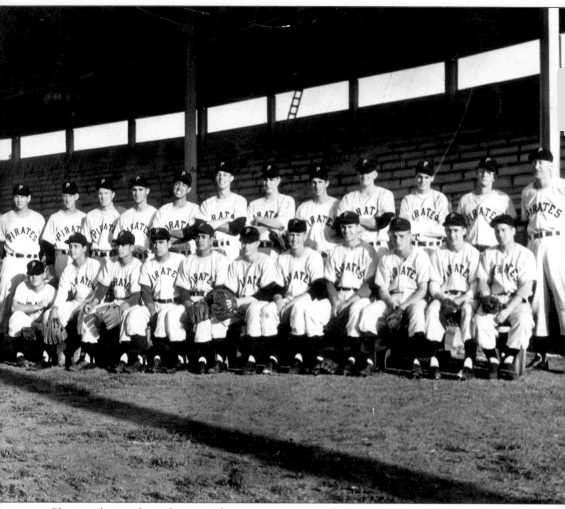

Photos taken early in the spring by any time were in sharp contrast to those taken later in the season. This is the earliest photo of the 1951 Bartlesville Pirates. Pictured from left to right are (front row) Francis "Wimpy" Mackall, Nick Genesta, Ernie Garcia, Oscar Buelna, Jose Martinez Cruz, Don Bryant, Don Cochran, E.C. Leslie, Lou Tond, Jack Quinn, and Al Solenberger; (back row) Bill Phillips, Dick Mc Kinley, Hal White, Manny LaCosta, Don Bussan, Kyle Bowers, Ron Kline, Otto Hatcher, Lee Branch, Ed Gigliotti, Dick Sutter, and Tedd Gullic. (Courtesy of Ronnie Kline.)

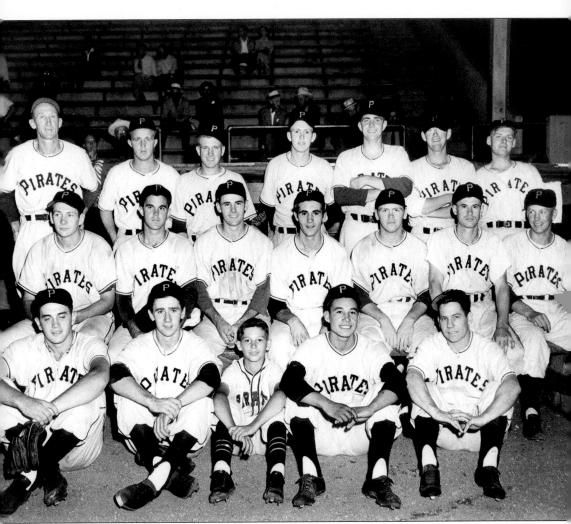

From the fellows shown in the photo on the opposite page, a number had been cut outright and others moved around the Pirate organization to make room for newer players such as Leo Kedzierski, Brandy Davis, Lou Tond, Hugh Casteix, Cotton Drummond, Merlin Jorgenson, and Joe Buckstead. Seen here from left to right are (front row) Segal "Cotton" Drummond, John Quinn, Phil Thompson (Batboy), Ernie Garcia and Al Solenberger. Middle Row: Bill Phillips, Hugh Casteix, Ernie Leslie, Manny LaCosta, Leo Kedzierski, Brandy Davis and Joe Buckstead. Back Row: Tedd Gullic (Manager), Lou Tond, Merlin Jorgenson, Don Cochran, Ronnie Kline, Dick Sutter and Dan Anderson. (Courtesy of Brandy Davis.)

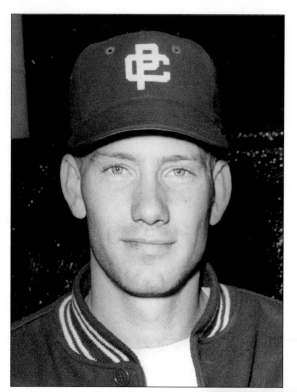

Joe Stanka started out in baseball to make a little extra money for his new family. He never intended that it would go past a summer or two in the Class D leagues. But the following career stops exemplify what a guy with talent can accomplish when he has a wife, like Jean, who was willing to sacrifice so that her husband could fulfill his goal of playing the game he loved: 1950 Shawnee, Sooner State, and Ponca City, KOM League; 1951 Ponca City KOM League; 1952 Pueblo, Colorado, Western League; 1953 Cedar Rapids, Three I League, Des Moines, Western League and Los Angeles, Pacific Coast League; 1954 Macon, Georgia, South Atlantic League and Los Angeles, Pacific Coast League; 1955 Des Moines, Western League and Los Angeles, Pacific Coast League; 1956–59 Sacramento, Pacific Coast League; 1959 Chicago, American League; 1960–65 Nankai Hawks, Osaka, Japanese major league. (Courtesy of Bob Dellinger.)

When Morris Mack of Aberdeen, South Dakota arrived in the KOM League he was hailed by Fletcher Cupp of the *Carthage Evening Press* as the guy who would be the next great "MM" to come out of the league. That was in obvious reference to Mickey Mantle. Mack was a fine third baseman for the Ponca City Dodgers in 1951 and part of 1952 before being sent to Lancaster, Pennsylvania in the Inter-State League. His career ended in 1953 after stops at Newport News, Virginia in the Piedmont League and Miami in the Florida International circuit. (Courtesy of Bob Dellinger.)

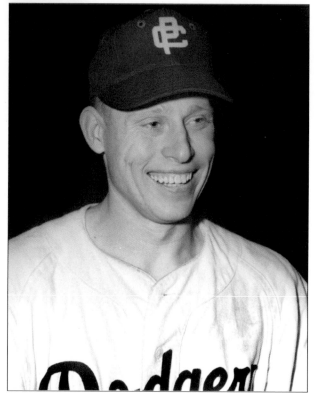

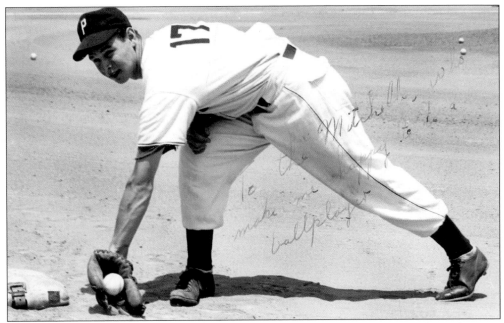

Loyd Wayne Simpson of Edwardsville, Illinois was signed by the St. Louis Browns and sent to the Pittsburg Browns in 1951. He was there for 84 games before playing another 32 games for the Miami Eagles. He was another of the Pittsburg Browns players to put his feet beneath the table of Loretta and Bob Mitchell and thus this photo is one he autographed and signed with the inscription: "To the Mitchells for making me so happy to be a ballplayer." (Courtesy of Jeanne Mitchell-Grisolano.)

Walter Babcock from Corwith, Iowa showed up in Carthage, Missouri in 1951 to hurl for the local Cub affiliate and to bring grief to the batboy. Of all the players this author came across during his batboy days, Babcock was the only one who remembered me a half-century later and not for a very flattering reason. The only source of water for the team was a five-gallon milk can. Someone dropped the "community cup" to the bottom of the container and didn't know how to get it out. Without any hesitation the batboy, Yours Truly, went over and stuck his arm all the way to the bottom of the can and proudly proclaimed victory. Babcock's career took him to Sioux Falls in 1952. In 1953 he served in the Army and played for the Ft. Leonard Wood, Missouri Hilltoppers. In 1953 he along with Whitey Herzog and others won the National Baseball Congress title at Wichita, Kansas. After the war Babcock played two more seasons going as high as Des Moines in the Western League and winding up his career in Paris. That is Paris as in Illinois, not France. (Courtesy of Walter Babcock.)

Duane Eugene Zimmer first showed up at Carthage as a shortstop in 1950. He came back in 1951 and stayed until early August when he was sent to Spindale, North Carolina in the Carolina League. The Bottineau, North Dakota native persisted and spent the 1952 and '53 seasons at Duluth in the Northern League. He caught on with Sioux City, Iowa of the Western League and Ogden, Utah of the Pioneer League in 1954. After playing semi-pro ball in Iowa in 1955 he concluded his playing career at Sioux City in 1956. For many years Zimmer was affiliated with the Omaha Royals in their sales department. At the 2003 KOM League reunion, in Carthage, he and wife Sue danced to the concluding song of the event. Four months later Duane passed away. Just weeks after her husband's death Sue had her leg amputated below the knee. Just four months later she drove from Omaha, Nebraska to Columbia, Missouri for the 2004 KOM League reunion, to honor the memory of her husband and to see in her minds eye, that "last dance" one more time. (Courtesy of Duane Zimmer.)

Brandy Davis started the 1951 season with Hutchinson, Kansas in the Western Association and homered in his first game. He was sent to Bartlesville on May 23 and remained in the KOM League until being called up to New Orleans of the Southern Association. He also homered in his final game with Bartlesville, and by virtue of that clout he led the KOM in round-trippers with 13. Davis was with the Pittsburg Pirates for parts of 1952 and 1953 but did not return to the major leagues until taking over as first base coach for the Phillies in 1982. He has played, managed, coached or scouted at the professional level since his rookie season in the KOM League, most recently as a scout for the Houston Astros during the 2004 season. (Courtesy of Brandy Davis.)

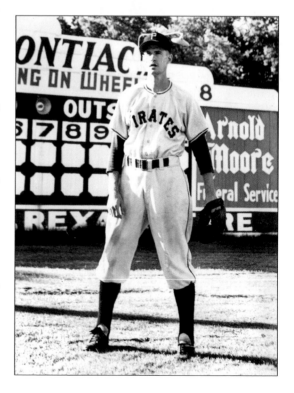

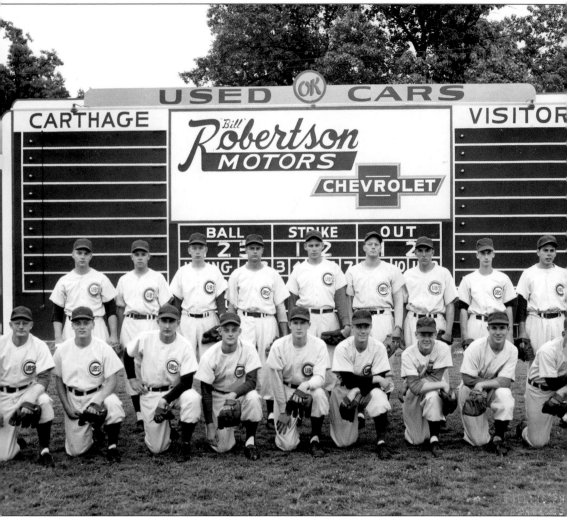

This is a club that meant a lot to Yours Truly, for I was the batboy until school started in early September when my mother made me quit. Too bad, they won the KOM League playoffs and I was at home listening on the radio. The 1951 Carthage Cibs, pictured from left to right, are (front row) Don Anderson (manager), Duane Zimmer, Bill Bauernfeind, John Mudd, Walt Babcock, Russ Oxford, Gary Hicks, Don Biebel, and Fred Bade; (back row) Wayne Baker, Bernie Tomicki, Jack Milster, Walter Koehler, Leonard Vandehey, Ernie Aiken, Tom Kordas, George Beck, and James Conroy. Walter Kohler was called back into the service on July 18, 1951, at the age of 26. He served as a medical corpsman and one year and one week later he was killed in battle. Finding out about his death, 43 years later, ranks as one of the saddest stories uncovered in a decade of researching the history of the KOM League.

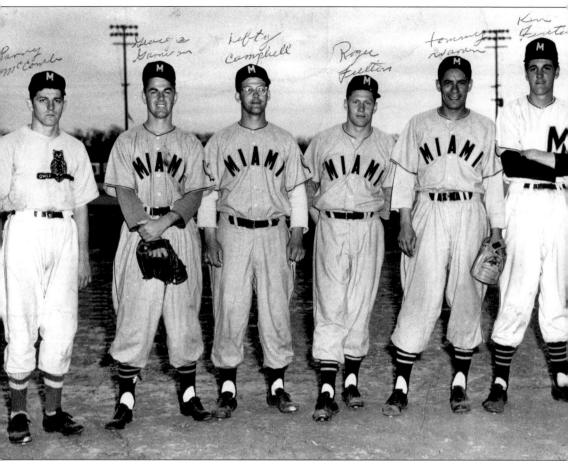

This photo is indicative of how difficult it was to come up with enough uniforms to take care of a team that hadn't cut their roster prior to the season opener. By 1951, when this photo was taken, the team was known as the Eagles. Larry McComb was wearing one of the old Miami Owls uniforms. This photo, from left to right, includes Larry McComb, George Garrison, Kenneth Campbell, Roger Fulton, Tommy Warren, and Ken Fentem. This was the projected pitching staff at the start of the season. Garrison, Campbell and Warren saw more action than the rest. Warren had played for the Brooklyn Dodgers in 1944 after returning from duty in the Navy. He was convicted on July 18, 1948, of larceny by fraud and was given a three-year sentence, but won permission from the Oklahoma Criminal Court of Appeals to play ball in Canada until October of 1948. His legal problems were due to some "tampering" with Tulsa County patrol cars that he restored and sold as new. The day in 1951 he was sentenced to another prison term, Yours Truly was with the Carthage Cubs on a road trip to Miami. Warren showed no affects of the adverse decision as he inserted himself as the starting pitcher and threw a 2-0 shutout. He played the 1952 season with the "State Prison Nine" at McAlester. After one year at McAlester he returned to professional baseball. He concluded his career with Wichita of the Western League in 1955. (Courtesy of Roger Fulton.)

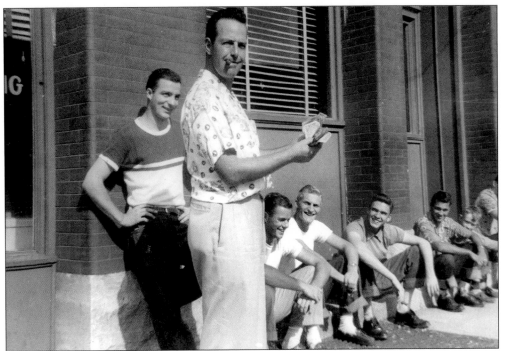

Manager Bill Enos of the 1951 Pittsburg Browns has a big cigar in his mouth as he prepares to dole out the meal money to his players prior to heading out for a road series. The excited players in the background, from left to right, are Frank Winkler, Hugh B. Lott, Tom Skole, Herb Fleisher, Lloyd Koehnke, and batboy Billy Bartley. (Courtesy of Jeanne Mitchell-Grisolano.)

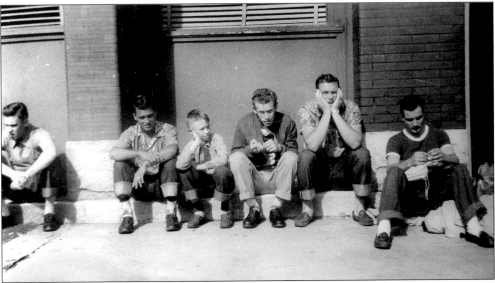

Happiness is a state of mind. After the players received their meager fare of $2.25 for three meals per day, and had time to contemplate the long bus ride to Ponca City, the mood turned to gloom. Pictured from left to right, Herb Fleisher, Lloyd Koehnke, Billy Bartley, Ken McGee, Pat Gosney and Frank Winkler show of the proper way blue jeans were cuffed. (Courtesy of Jeanne Mitchell-Grisolano.)

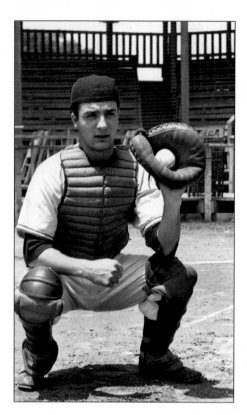

Frank Winkler not only looked like a catcher he also shared the best fielding average among all catchers in league history who caught 100 or more games. His .982 tied him with Jim Hansen, who posted the same number in 1949. Not much is known about Winkler. He had started his career in 1947 with Wausau in the Wisconsin State League and also played in 1949 with Globe-Miami, Arizona in the Arizona-Texas League. He was a native of Detroit, Michigan. (Courtesy of Jeanne Mitchell-Grisolano.)

There were only two players from Hawaii to play in the KOM League. George Dias, a pitcher, pictured here on North Broadway in Pittsburg, Kansas was one of them. He joined the team from the Aberdeen, South Dakota Pheasants and had nine decisions. Seven were losses. The other Hawaiian on the team was Stanley Costales. Dias and Costales ate many meals at the home of Loretta and Bob Mitchell. To reciprocate for the kindness showed her son by the Mitchell family, Mrs. Costales sent large supplies of expensive macadamia nuts from Honolulu on a regular basis. (Courtesy of Jeanne Mitchell-Grisolano.)

Walt Kohler (left) and Bernie Tomicki shake hands before Koehler takes the mound for one of his 13th appearances in 1951. Before Kohler could make it to his 14th game he was on active duty. Prior to coming from his home in Lansing, Michigan he was informed he would not be called to serve in Korea due to his age. However, this author recalls seeing him very troubled when he would come from the pay telephone booth at the Carthage ballpark during early morning workouts. He must have pled with his draft board to be able to conclude the 1951 season before going into the heat of battle of the Korean War. He lost on all counts and the young groom never lived to see his 28th birthday. Nor did he live long enough to find out that the guy from the Joplin Miners who battered him around in his mound debut with Springfield, Missouri in 1950 went on to become a Hall of Famer. Yep, Walt Koehler was one of the first pitchers in the Western Association to give up solid blows to Mickey Mantle. (Courtesy of Bill Bauernfeind.)

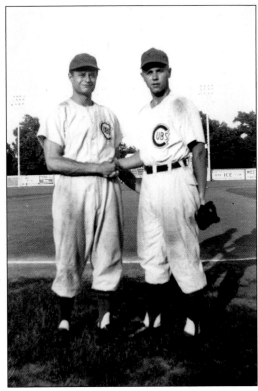

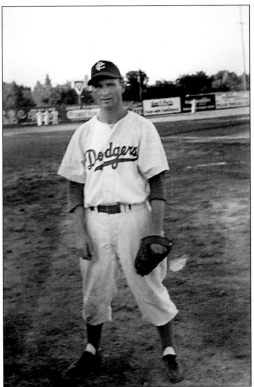

By the time the 1951 season rolled around, George Scherger of Dickinson, North Dakota had spent a decade playing "bush league" baseball, except for the war years. He replaced Boyd Bartley as the Ponca City manager and also took on the role as second baseman. Scherger was a minor league player and manager from 1940 through 1982, except for the period of 1970–1978 when he coached with the Cincinnati Reds. Under Scherger's leadership, Ponca City posted the best won-loss record, 85-40, in league history. (Courtesy of Bob Dellinger.)

*Carthage Baseball Association, Inc.*

"MEMBER OF THE KANSAS-OKLAHOMA-MISSOURI LEAGUE"

*Carthage, Missouri*

At a meeting of the membership of the Carthage Baseball Association held in the Knell mortuary on the 8th. day of April, 1952 the following members were present:

| | | |
|---|---|---|
| Gene Follmer | L. E. Newman | W. M. Eaker |
| Harry Schermer | Frank Knell | J. M. Owen |
| Rueul King | K. R. Sims | J. D. Reynolds |

A resolution was offered by Rueul King favoring the dissolution of the Carthage Baseball Association stating that all debts, claims and other obligations of said association have been compromised and satisfied to the extent of the total assets of said corporation and that a copy of such resolution duly verified be filed with the Secretary of State of the State of Missouri as prima facie evidence of such dissolution. Said resolution was seconded by Kenneth Sims and after full discussion was adopted by unanimous vote of all members present.

Kenneth R. Sims, Secretary

County of Jasper
State of Missouri

Sworn to before me this 8th. day of April, 1952

Notary Public

My commission expires *June 4, 1954*

This document announced "The End" of Carthage Baseball. Three weeks prior to the start of the 1952 season Carthage had to pull out of the league due to financial reasons. The reasons stemmed from the fact the Chicago Cubs withheld $6,000 they had promised to ante up if Carthage would protect two players by putting them on the disabled list. Carthage lived up to their agreement but when they tried to collect in 1952, the Cubs minor league director balked. He said it wasn't in writing, and that consequently the Cubs owed Carthage nothing. The board of directors convened and signed the dissolution statement on April 8, 1952, and it was filed in the Jasper County Recorder of Deeds office one week later. That ended Carthage's involvement in minor league baseball and the remainder of the league would fold at the end of the 1952 campaign. (Courtesy of the Reuel King family.)

# SEVEN

# The 1952 Season

## *The Swan Song of*

## *a Great League*

The news of 1952 revolved around political elections, war, sports and the love lives of the rich and famous. Sound familiar?

If you are a history buff, to whom did Jacqueline Bouvier become engaged on June 20? Give you a hint—his first name was John. You all guessed John G.W. Husted didn't you? Well, give yourself an "A" for doing so. G.W. was from Bedford Hills, New York and was affiliated with the Brokerage Firm of Dominick & Dominick. If you guessed John F. Kennedy, try the next trivia question.

What significant event occurred on April 15, 1952? If you said that it was the day Harry S. Truman signed the Japanese peace treaty, granting them full sovereignty and officially ending W.W.II, in the Pacific, you are too intelligent to read the rest of this book.

President Truman and the KOM League had a lot in common. He and the old league started together and folded the same year. Truman officially pulled out of the race on March 29th and left it wide open for guys like Stevenson and Kefauver.

Elizabeth Taylor was 19 and dumped Conrad Hilton in favor of Mike Wilding. Elizabeth enjoyed her femininity while George Jorgenson wished he could. According to press reports of the day, "A scrawny GI flew to Copenhagen, Denmark, had 2,000 hormone injections, six operations and returned to America as Christine Jorgenson."

If you had a TV in 1952 the top headliners were Jack Benny and Imogene Coca. For the majority of us we had only radio and the top pair on that medium was Arthur Godfrey and Tullulah Bankhead.

In the boxing ring Rocky Marciano won his 39th fight in a row by defeating Lee Savold. Sen. William Benton was fighting with Sen. Joe McCarthy, who he called another Hitler. McCarthy counterpunched and sued Benton for libel and conspiracy.

The Olympics of 1952 belonged to the Zatopek family. Emil won three Gold Medals. Running in his first marathon, he easily won. When asked what it was like to win the race he replied, "Boring." Emil's wife, Dana, won the javelin toss by 15 feet over the world's record.

Another girl named Elizabeth, age 25, was Princess when she left the country on February 8. When she returned home she was the Queen of England. Her daddy, King George VI, died while she was "off running around."

General Motors announced on July 14—when else?—that they had perfected an air conditioner for cars. It was to be an optional item on 1953 models

Many a ballplayer had uttered, "have a heart" to unsympathetic umpires. Pete During, a 41-year-old Bethlehem Steel worker, got the first mechanical one.

Some of the world's funniest characters died in 1952. Jerome "Curly" Howard, a member of the "Three Stooges" passed on January 18. The NFL bought the New York Yankees for

$300,000 and sent them to Dallas. The team lost $250,000 and it too died.

Troy Ruttman won the Indy 500 and got $63,000, Sam Snead won the Masters Golf Tournament for $4,000, the Yankees got $6,026.32 per player for winning the World Series and the Brooklyn Dodgers got $4,200.64 for losing.

Jackie Robinson had a great year beginning with receiving the largest salary in Brooklyn Dodger history and becoming the first person of his race to be named to an executive position with either a radio or TV network. NBC hired him to head their community relations program. He went on to play in the World Series and his Dodgers were nosed out in seven games by the Yanks.

Mickey Mantle "flunked" his Army physical, John Mize became the third man to homer in every Major League park, and Minor League President George Trautman flipped when the Harrisburg, Pennsylvania Senators signed a woman player, Walt Dropo who had 12 straight hits.

On June 27, Elmo Lincoln died and three months later the KOM League played its last game. What did Elmo Lincoln and the KOM League have in common? Both were on the "ropes" most of the time they were in the limelight. Elmo was the first man to play Tarzan on the silver screen and his name is only a footnote in history.

In an attempt to keep the memory of the KOM League alive this chapter deals with the old Class D league's final season—1952. Might just as well dedicate this chapter to Elmo's memory.

## SUMMARY OF KOM LEAGUE DATA FOR 1952

| Team Standings | Won | Lost | Pct. | GB |
|---|---|---|---|---|
| Iola Indians | *79 | 47 | .627 | — |
| Miami Eagles | *67 | 57 | .5403 | 11 |
| Ponca City Dodgers | *68 | 58 | .5396 | 11 |
| B'ville/Pittsburg Pirates | *59 | 65 | .476 | 19 |
| Blackwell Broncos | *57 | 69 | .452 | 22 |
| Independence Browns | 46 | 80 | .365 | 33 |

*Indicates tie

Miami beat Ponca City, 2 games to 0 to win the playoffs.

### LEAGUE LEADERS

#### BATTING
Average: .335, John Vossen, Miami Eagles
Home runs: 24, Don Ervin, Miami Eagles
RBI: 116, John Davenport, Miami Eagles
Stolen bases: 103, Paul Weeks, Iola Indians

#### PITCHING
ERA: 1.76, Jim Owens, Miami Eagles
Wins: 26-6, Joe Vilk, Iola Indians
Strikeouts: 300, Jim Owens
Shutouts: 5-Jim Owens

#### ATTENDANCE
Bartlesville/Pittsburg: 34,267
Blackwell: 51,000
Iola: 42,327
Miami: 43,008
Independence: 39,487
Ponca City: 55,276*

*With a special promotion this team drew the all-time record crowd of 7,125 for a Class D baseball game.

## PLAYERS FROM 1952 KOM LEAGUE TEAMS EHO MADE IT TO THE MAJOR LEAGUES

Miami: Seth Marvin Morehead and James Philip Owens
Blackwell: Andrew Varga had been on the Chicago Cub roster in both 1950 and 1951 and
wound up in Class D by 1952.

## MANAGERS IN THE KOM LEAGUE IN 1952 WITH PREVIOUS MAJOR LEAGUE EXPERIENCE

Bartlesville/Pittsburg: Hershel Martin
Ponca City: Boyd Bartley

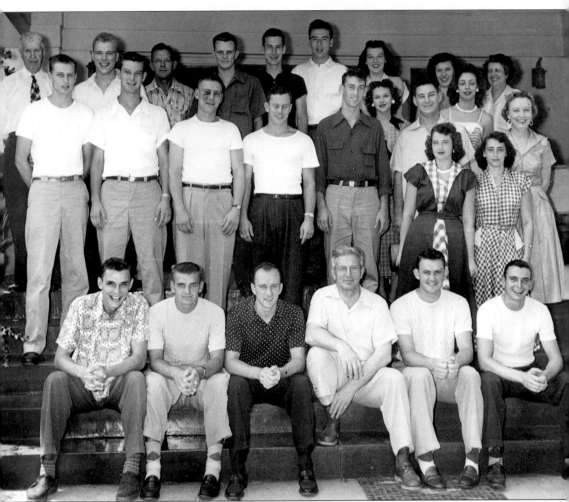

The Carthage Cubs were gone in 1952 and the recipient of the team was Blackwell, Oklahoma.
This picture was taken in front of the Alfred Porter home after a meal they served the team.
Mr. Porter, aside from being Mayor, also ran a Funeral home in Blackwell. Pictured from left to
right are (first row) Tom Kordas, Stan Bonczek, Don Geresy, Mayor Alfred Porter, Danny
Priest, and Wayne Benstead; (second row) Tom Guderian, Harold Summer, Fred Bade, Tom
Paddock, Roy Sorenson, Mrs. Don Geresy, Don Keeter (in front of Don, Mrs. Keeter), Jean
Gargus, Glenda Ruggs, and Mrs. Al Reitz; (third row)Tom Kordas, Stan Bonczek, Don Geresy,
Mayor Alfred Porter, Danny Priest, and Wayne Benstead; (fourth row) Mr. Tarbut, Walter
Vonderheide, Al Reitz, Joe Adametz, George Beck, Andy Varga, Mrs. Andy Varga, Pat
Freeman, and Mrs. Alfred Porter. (Courtesy of Don Keeter.)

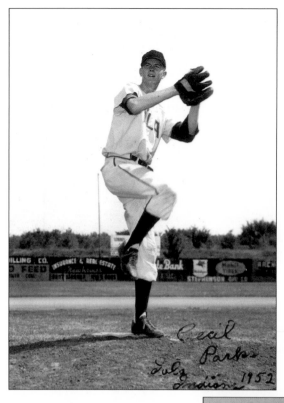

Three young men from Carthage, Missouri played in the KOM League. They were Wally Sparks of the 1951 Iola Indians, Frank Urban of the 1947 and '48 Chanute teams, and Cecil Parks. Parks, featured in this photo, came to the attention of Iola manager Woody Fair, a Carthage resident, who was aware of Parks' prowess in the local Twilight League. He was placed on the 1952 Iola roster during the latter stages of the season, as Fair was bolstering his pitching staff for the stretch drive. (Courtesy of the Cecil Parks family.)

William Wigle of Amhertsburg, Ontario, Canada was the only left-hander in KOM League history to win 20 games during the regular season. He had started his career in 1946 at Jamestown New York in the PONY League. He pitched for Hagerstown, Maryland for two years in the Inter-State League and had pitched in the Piedmont, Carolina and Florida International leagues before arriving in Iola. By then he was a 32-year-old veteran who knew how to pitch. By 1952 the supply of 19 to 20-year-old American performers were wearing uniforms other than the baseball variety. The KOM League had many players by that time from both north and south of the border. (Courtesy of the William Wigle family.)

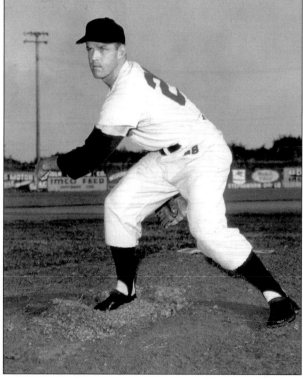

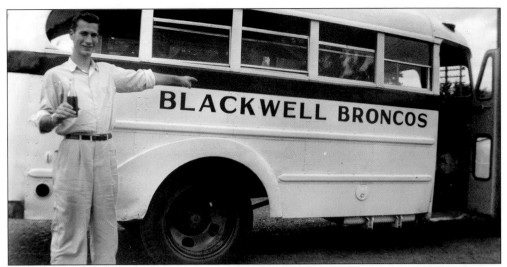

One thing the Carthage Cubs of 1951, who went to Blackwell, Oklahoma in 1952, didn't miss was the old Carthage bus. Here George Beck, a pitcher and first baseman for both those teams, admires his new mode of transportation. The old Carthage bus didn't possess a dependable breaking system. Many times, to avoid a collision, the driver would steer the bus up an embankment or put off to the shoulder and pray the bus didn't hit something before stopping. Another thing the old bus lacked was a floorboard. The spaces in the floor were just another means of air-conditioning. The other was opening all the windows. It didn't much matter if it rained or not. If the windows were closed to keep out the water it would just come through the spaces where the floorboard used to be. Ah yes, there is little nostalgia for the bus rides of the late 1940s and early 1950s. (Courtesy of George Beck.)

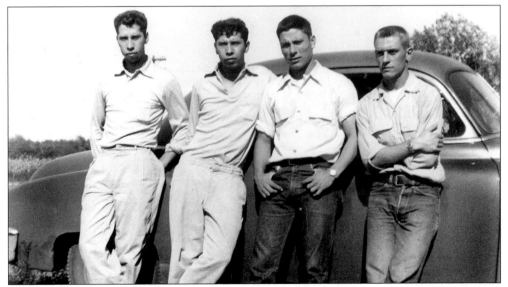

There were three sets of twins in KOM League history and all of them played in the 1952 season. This Bartlesville photo of 1952 features one set of twins. Pictured rom left to right are Ernie Abril, Manny Abril, Joe Fishinghawk and Erv Hartman. Harold and Gerald Crucani played at Blackwell, Oklahoma. The other set of twins played at Independence (*see page 126*). (Courtesy of Joe Fishinghawk.)

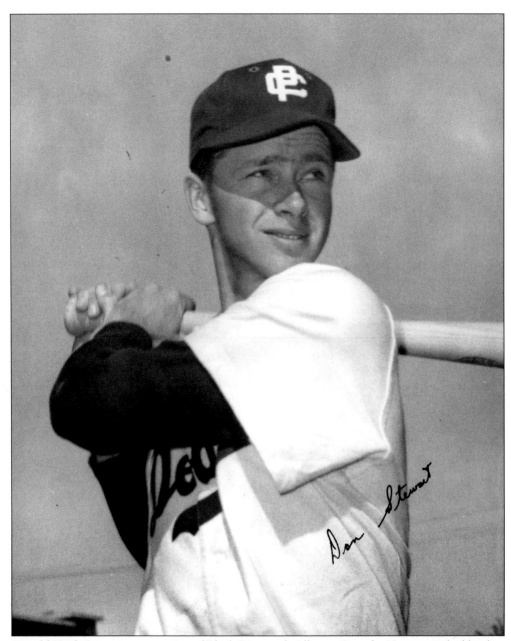

Donald Hugh Stewart was a native of Black Diamond, Alberta, Canada. He was a gifted hockey player and played professional hockey as well as baseball. He had two seasons, 1951 and 1952, in the KOM League and then one more year in the pro ranks with Santa Barbara of the California League. After the 1953 season his baseball was confined to the semi-pro ranks. In 1955 he was the player/manager of the Lloydminster, Alberta club in the Western Canada League and took that team to the Global World Series in Milwaukee. (Courtesy of Bob Dellinger.)

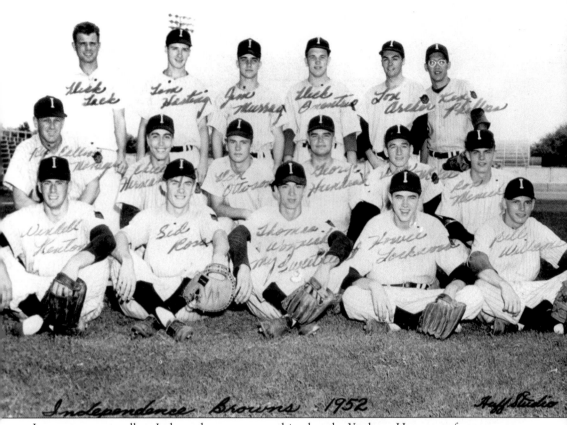

It was strange to call an Independence team anything but the Yankees. However, after a one-year absence, Independence came back into the KOM League as an affiliate of the St. Louis Browns. The autographs on this photo all have a striking similarity. It is suspected that one individual placed all the names there. Team member, pictured from left to right with position(s) listed, are (front row) Wendell Clifton (P), Sidney Ross (C), Tom Wozniak (P), Howard Lockwood (P), and Bill Williams (P); (middle row) Frederick Collins (manager/1B), Sam "Chico" Hernandez (2B), Don Ottoson (LF), George Hunrick (C), Verne McKee (OF), and Ron Minnich (OF/P); (back row) Dick Lack (LF), Tim Hastings (LB/OF), Jim Murray (3B), Richard Quattrin (P), Lou Archer (P), and Ken Phillips (SS). (Courtesy of the Tom Wozniak family.)

Elbert Jarvis was a 20-year-old first basemen for the Ponca City Dodgers in 1952. He was inducted into the US Army at the close of the 1952 season. In 1955 he returned to professional baseball with Shawnee, Oklahoma in the Sooner State League. In 1956 he played with Cedar Rapids, Iowa in the Three-I League. Jarvis was an avid fisherman and enjoyed fishing in Lake Ponca in the town where he had begun his baseball career. On a fishing trip to that lake on May 28, 1958, he tragically drowned at the age of 26. (Courtesy of Bob Dellinger.)

**1952**
Price—10 cents

BASEBALL

PRIZE
PROGRAM

Your Lucky Number   N⁰ 0864

Tear off stub and place in box
— Prizes Every Night —

BLACKWELL BRONCOS

The Blackwell Broncos, the successor to the Carthage Cubs, did something the Carthage organization never accomplished in six years. They produced a scorecard. Also, Blackwell accomplished another feat in the attendance realm that Carthage never attained. They drew 51,000 paying customers to see a club finish 5th in a six team race. The Blackwell fans had waited a long time for minor league baseball and they savored it another two years as a member of the Western Association

| "BRONCOS" AT HOME | "BRONCOS" AWAY |
|---|---|
| **WITH BARTLESVILLE**<br>May 2, 3, 4      June 1, 2, 3      July 1, 2, 3<br>August 2, 3, 4 | **WITH PONCA CITY**<br>April 29, 30 & May 1          May 29, 30, 31<br>June 28, 29, 30      July 30, 31, Aug. 1<br>August 29, 30, 31 |
| **WITH INDEPENDENCE**<br>May 11, 12, 13   June 10, 11, 12   July 12, 13, 14<br>August 11, 12, 13 | **WITH IOLA**<br>May 5, 6, 7      June 4, 5, 6      July 4, 5, 6<br>August 5, 6, 7 |
| **WITH MIAMI**<br>May 14, 15, 16   June 13, 14, 15   July 15, 16, 17<br>August 14, 15, 16 | **WITH MIAMI**<br>May 8, 9, 10      June 7, 8, 9      July 7, 8, 9<br>August 8, 9, 10 |
| **WITH PONCA CITY**<br>May 20, 21, 22   June 19, 20, 21   July 21, 22, 23<br>August 20, 21, 22   September 1, 2, 3 | **WITH BARTLESVILLE**<br>May 17, 18, 19   June 16, 17, 18   July 18, 19, 20<br>August 17, 18, 19 |
| **WITH IOLA**<br>May 23, 24, 25   June 22, 23, 24   July 24, 25, 26<br>August 23, 24, 25 | **WITH INDEPENDENCE**<br>May 26, 27, 28   June 25, 26, 27   July 27, 28, 29<br>August 26, 27, 28 |

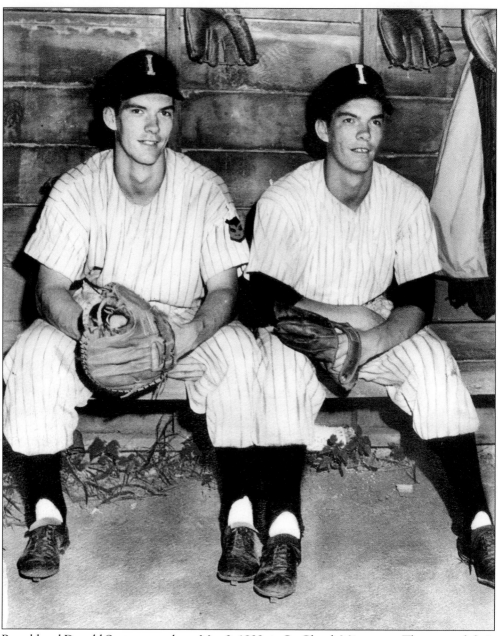

Ronald and Donald Saatzer were born May 3, 1933, in St. Cloud, Minnesota. They started their careers with Fond du Lac in the Wisconsin State League in 1952 and then moved to the heat of the KOM League later that season. One of the boys wrote a letter to their parents claiming it was so hot in Kansas that the trees were leaning toward the dogs. In a bit of irony the Saatzer twins joined the McAlester, Oklahoma Rockets in the Sooner State League in 1953. The Yankees had just signed the twin brothers of Mickey Mantle. Ray and Roy Mantle provided McAlester with two sets of twins that year. To make it a bit more confusing the Yankees also assigned their cousin, Max, to the same club. During some McAlester games there were three Mantles and two Saatzers in the lineup. In this photo Don, the catcher, is on the left and Ron, the pitcher, is on the right. (Courtesy of Don Saatzer.)

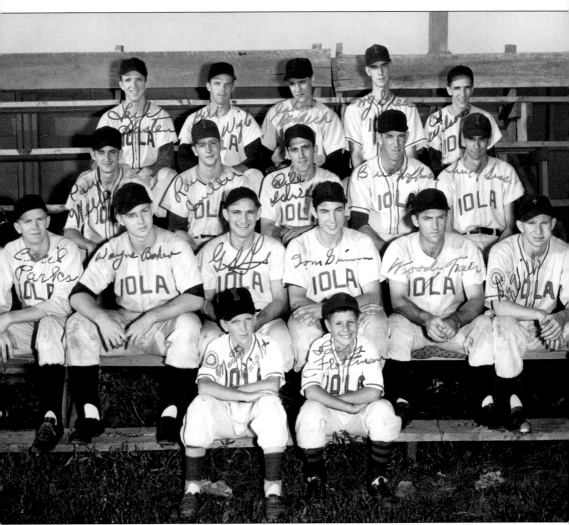

The Iola Indians were the final pennant winning team in the brief history of the KOM League. In this "really" autographed photo, pictured from left to right, are (up front) batboys Martin Wright and Larry Flottman; (front row) Cecil Parks, Wayne Baker, Gaspar del Toro, Tom Guinn, Woody Fair, and Joe Vilk; (middle row) Paul Weeks, Roy Coulter, Bill Schrier, Harold "Bus" Hoffman, and Chuck Sisson; (back row) Jack Hasten, Bill Wigle, John Brkich, Jerry Gleason, and Ed Wilson. (Courtesy of Woody Fair.)

The Miami Eagles prevailed in the KOM League playoffs to become the last KOM League team to post a victory. Back in 1946, Miami played Bartlesville in an afternoon game, thus that franchise participated in the first and last game in league history. This photo of the Miami Eagles was taken August 28, 1952. Pictured from left to right, with position(s) listed, are (front row) Billy Ray Long (P) and Eddie Sack (C); (middle row) Seth Morehead (P), Gene Melito (P), Jim McHugh (2B), Denny Hamilton (P), Bob Bandelier (P), Dick McKinley (P), and Jackie Horner (batboy); (back row) Don Ervin (LF), John Vossen (CF), Raymond Von Hagle (C), Jerry Dodds (3B), Jim Owens (P), Ed Rommel (SS), Johnny Davenport (1B/manager), and Ray Vanderberg (business manager). From this group, Seth Morehead and Jim Owens went to the Major Leagues.

A lot happened in the seven-year period the KOM League functioned and over a half-century after its demise there are still many people who have fond memories of a time that will only be forgotten if those who loved the old league allow it to happen. Books such as this are a way to perpetuate "The Golden Era" of minor league baseball.